10/99

THE BEGINNER'S GUIDE TO
Still Life Drawing

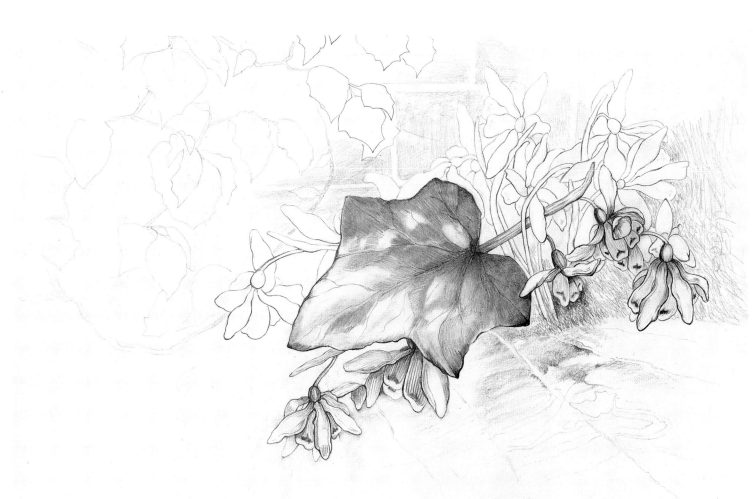

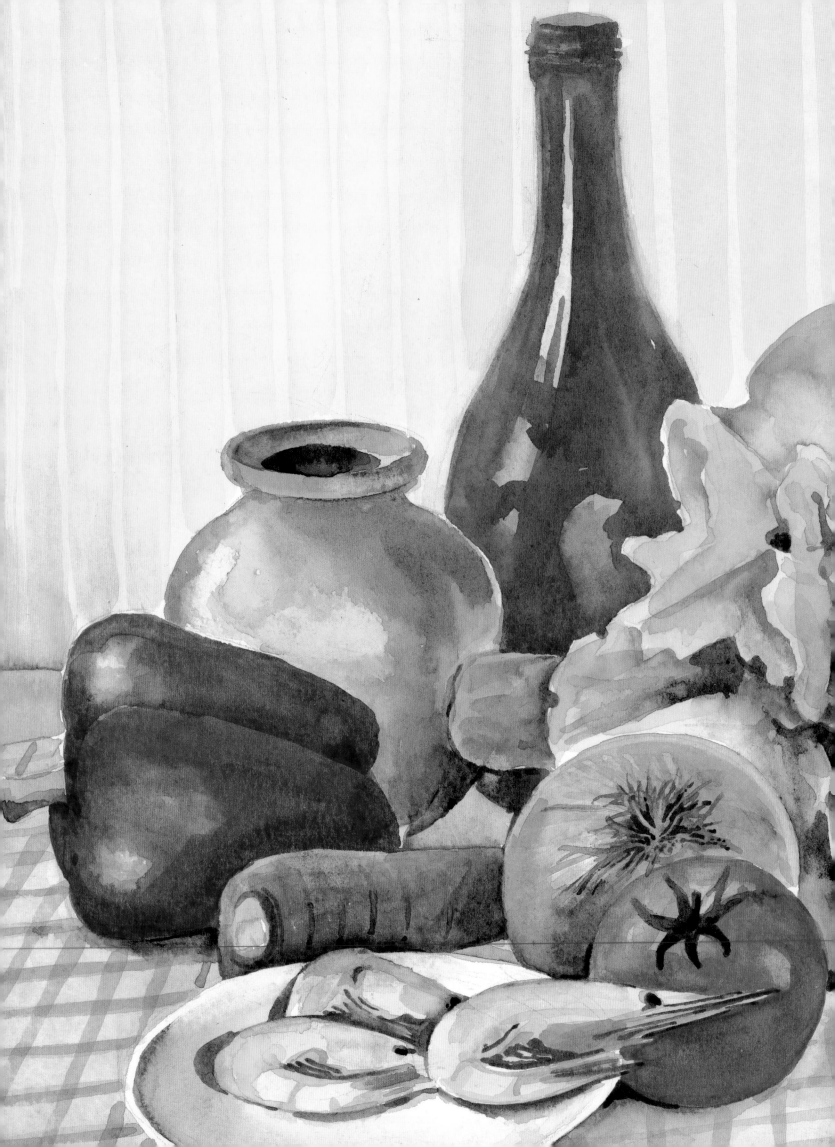

THE BEGINNER'S GUIDE TO
Still Life Drawing

Alan Moss

CHARTWELL
BOOKS, INC.

Published by
CHARTWELL BOOKS, INC.
A Division of BOOK SALES, INC.
110 Enterprise Avenue
Secaucus, New Jersey 07094

Produced by
Brompton Books Corp.
15 Sherwood Place
Greenwich, CT 06830

ISBN 1-55521-852-0

Printed in Hong Kong

PAGE 1
This delicate pencil drawing uses the range of the medium
to combine a high degree of finish with considerable detail.

PAGES 2/3
Still Life with Lettuce, watercolor.

PAGES 4/5
Still Life with Pine Cone, charcoal on tone paper.

Contents

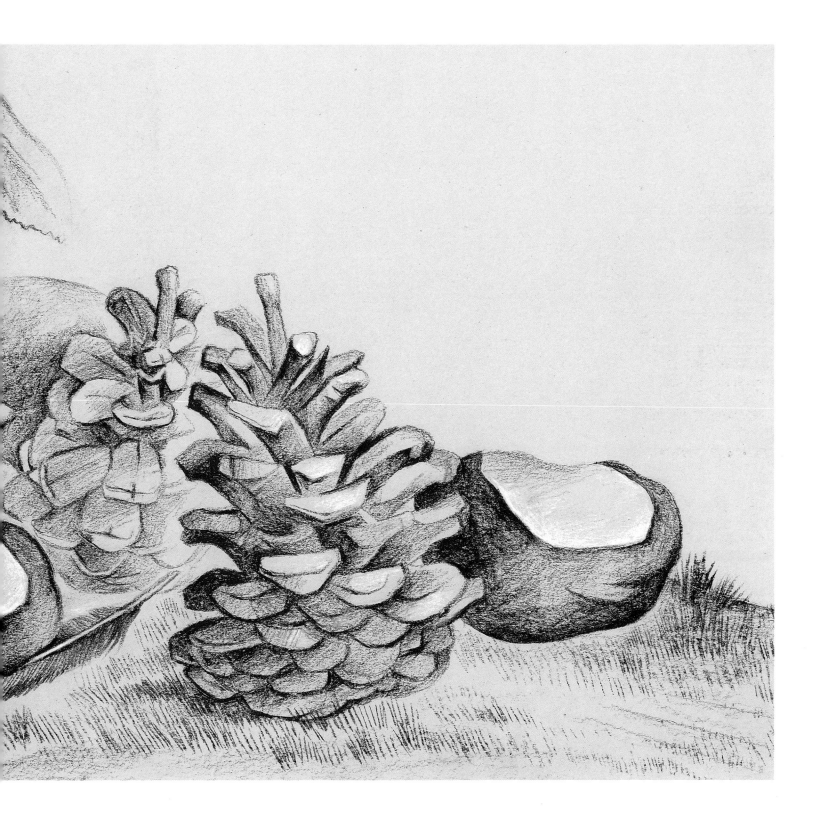

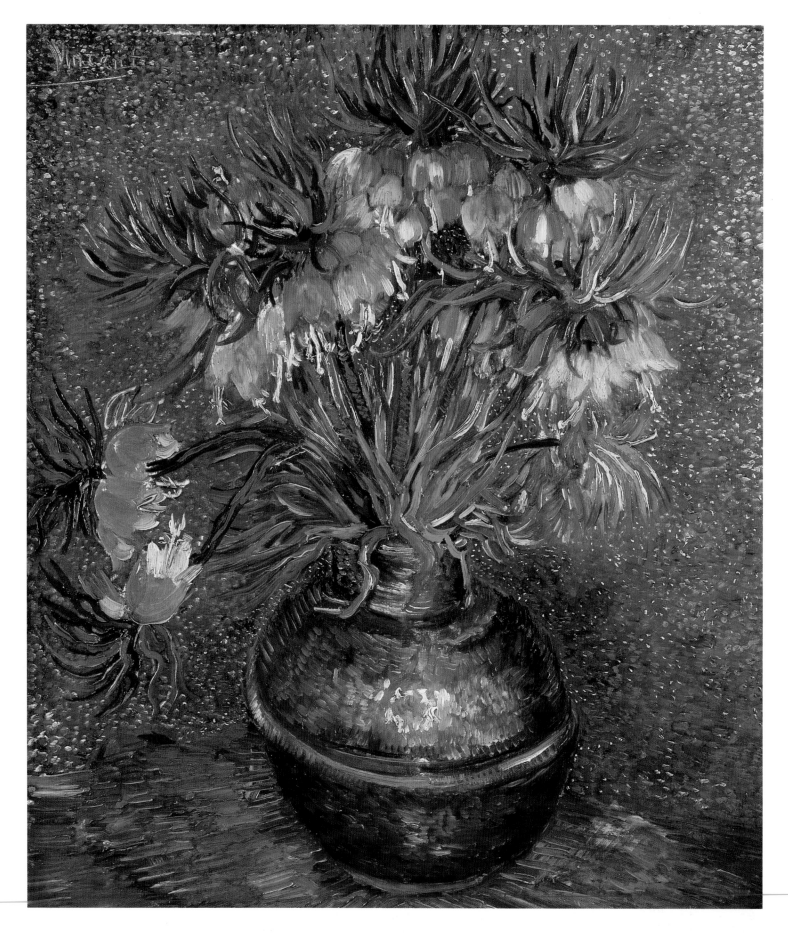

Introduction

Just as tourists looking for a useful guide may be seeking reassurance as well as information, so a beginner about to take up drawing might also hope to soothe doubts by finding a helpful guidebook which suggests a departure point, an appropriate route and an indication of the expected time and place of arrival.

It is the intention of this book to offer the beginner a series of still-life exercises with simple steps and clear instructions, to explain the basic and essential principles of drawing and to help bring about improvements and foster an understanding of the skills needed in handling the medium and the subject. By concentrating on still life and drawing, the book avoids giving confusing and conflicting advice, which may happen when too much ground is covered. One of the important things to establish at the outset is a common denominator which can provide a basis for varying attitudes and notions and enable any beginner to have the same starting point. For most beginners that means working with the familiar and using a recognizable image rather than an abstract or imaginative source.

In order to imitate 'reality' the first step must be direct observation of the visible and physical world, so that the experience of light, shade, shape, etc, can be represented on paper. The expression of this knowledge is achieved through the concept of form and space, which leads to the question of an objective viewpoint, as with a camera, but influenced by subjective choices of interpretation.

As there can be many ingredients in building up a complete painting or drawing, some insight of what goes into its make-up is crucial. The process of picture-making, which involves creating illusions of form (space) and includes individual preferences as to content and various styles of composition, is explained in simple and informative terms in the diagram below.

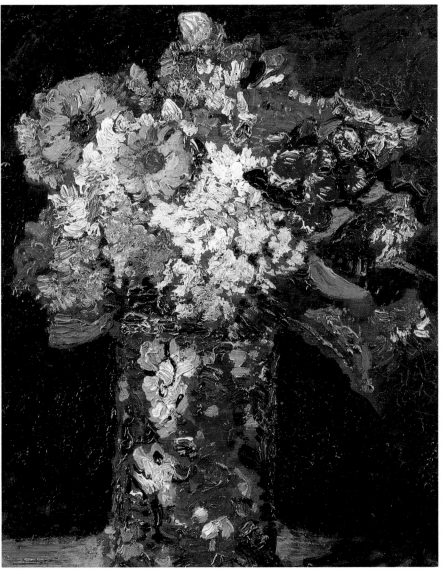

Form (Space)	(Objective) Representation	Technique
3D ——— ← —————————— → ——— 2D		
Perception	(Subjective) Interpretation	Illusion

Content ← Analysis	(Objective) Concept	Effect → Medium
↑	↑	↑
Form (Space)	Representation	Technique
3D ——————— ← —————————— → ——————— 2D		
Perception	Interpretation	Illusion
↑	↑	↑
Subject Cause	(Subjective) Expression	Synthesis Style

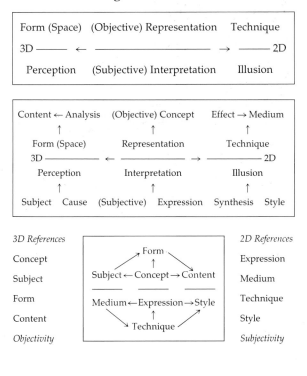

3D References

Concept

Subject

Form

Content

Objectivity

 Form
 ↑
Subject ← Concept → Content

Medium ← Expression → Style
 ↑
 Technique

2D References

Expression

Medium

Technique

Style

Subjectivity

The Historical Context

Many artists have attained the highest point of their artistic achievements through the medium of still life. At one time it was so limited and despised that the only place still life representations might be found was on the back of other pictures, but in the twentieth century still life has emerged as a creative force in its own right.

The Greeks and Romans are known to have painted pictures of food, but still life as such was not a feature of either medieval or Renaissance art, although still-life details were included into some larger compositions. The first still life paintings as such were produed in the Netherlands after the Reformation, when the disappearance of church patronage meant that professional painters turned to a secular market with more material and mundane interests. The seventeenth century, the Golden Age of Dutch art, also saw the flowering of Dutch still life and the creation of specializations. Elsewhere in Europe the genre did not have such a vogue at this time. Exceptions are the work of Caravaggio, who painted baskets of fruit, and the still lifes that Velasquez introduced as part of his subject matter, for example in his 'shop pieces'.

It was left to the French painter Chardin in the eighteenth century to bring a fresh and sensitive vision to this art form. He was less interested in the decorative effect of still life arrangements, concentrating rather on the appearance of the objects themselves, and transforming even commonplace items by giving them a tangible sense of grandeur. His work influenced the artists of the Realist movement in the mid-nineteenth century, such as Corot, Courbet and Manet, who were concerned above all with the aesthetic qualities of the still life.

With the still-life work of Cézanne, who used it as the main medium for his innovatory structural experiments, the form developed still further. Matisse explored color through still life, and it became an essential form for Braque and Gris to analyse in Cubism. The Surrealists, Chirico and Magritte, ignored the outside world to reveal objects from their innermost dreams, imagination and fantasy, while at the same time Morandi was exploiting a restricted palette and a narrow discipline of still life. In the 1950s and 1960s Pop Art revitalized the figurative tradition by focusing on the consumer goods of the modern age as still-life subjects.

ABOVE
Giorgio Morandi
Still Life With Bottles
Oil on canvas

RIGHT
René Magritte
The Reckless Sleeper 1927
Oil on canvas, 45½ × 32 inches (115.6 × 81.3 cm)

A Practical Guide

The following are guidelines to the range of subjects that will be covered in the exercises in this book.

Materials and Methods

Subject Fruit, vegetables, flowers, plants, cones, shells, toys, containers, etc: a list of readily available subject matter presenting opportunities for many combinations of underlying themes.

Medium Pencil, pen, charcoal, pastel, watercolor, gouache, collage, montage: a range of media, with marks made by brush, stick and point to show the character of the materials.

Form (Space) Volume, depth, mass, dimension, solidity, scale, figure, ground: different aspects of representation that can be constantly related to objectivity.

Technique Line, shape, tone, color, proportion, perspective, texture, surface: the ingredients for creating an illusion which serves form (space) as an end by a variety of methods.

Content Geometric, organic, natural, manufactured, material, spiritual, intellectual, emotional: a variety of factors deter-

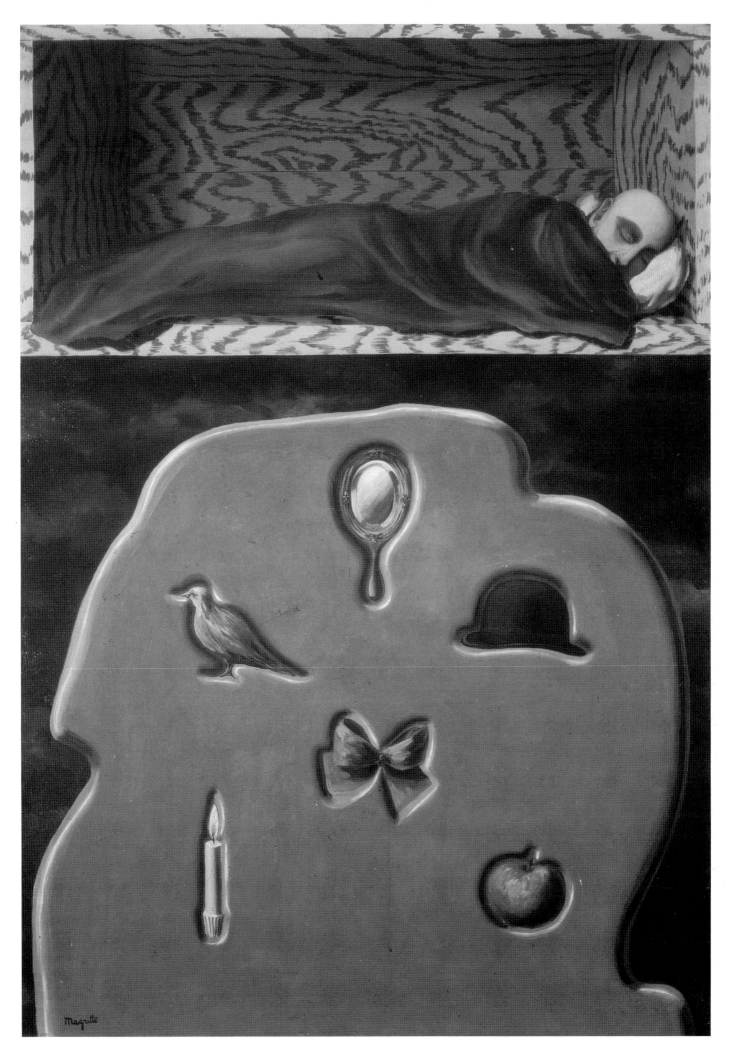

mined by individual preference, with many variations.

Style Contrast, balance, design, structure, rhythm, harmony, pattern, decoration: the elements of composition using subjective criteria to determine their use.

'Nature seen through a temperament' – Matthew Arnold on Art.

Checklist

To save repeating reminders and explanations, here are some points which turn up at regular intervals.

Procedure for drawing and measuring Draw or measure across the paper or subject toward your drawing hand. If you are right-handed, draw diagonally toward the right, and vice versa for left-handed. Adopt a similar procedure for taking up position for drawing direct; keep the subject above or on the opposite side to your drawing hand. Work with the drawing upright when possible; a drawing board is a useful acquisition.

Cut-out frame A simple cut-out frame is like a slide mount. It should be in the pro-

portions of 1:1.5 and marked off at ¼, ½ and ¾ points. Looking through the frame at the subject helps in selecting and composing an image.

Time and size The time needed to complete an exercise depends on the use of medium, size of paper, and your own pace of working. It takes longer to draw tonally with a pencil on a large scale than it does in line on a small scale. Vary size, time, technique, medium and subject.

Thumbnail sketches Save time, space, energy and mistakes by doing small and preliminary estimates of the subject.

Lighting and setting Try working under different light conditions, natural, artificial, bright, subdued, candlelight, spotlight, with changes of interior and exterior settings.

Further study Switch topics from one medium to another as a related study, or carry an idea through as an extended study. Use student quality materials to begin with and introduce artist's quality when you begin to feel competent.

BELOW
David Hockney
Still Life: Glass Table
Oil on canvas

RIGHT
Henri Matisse
Red Interior: Still Life on a Blue Table 1947
Oil on canvas

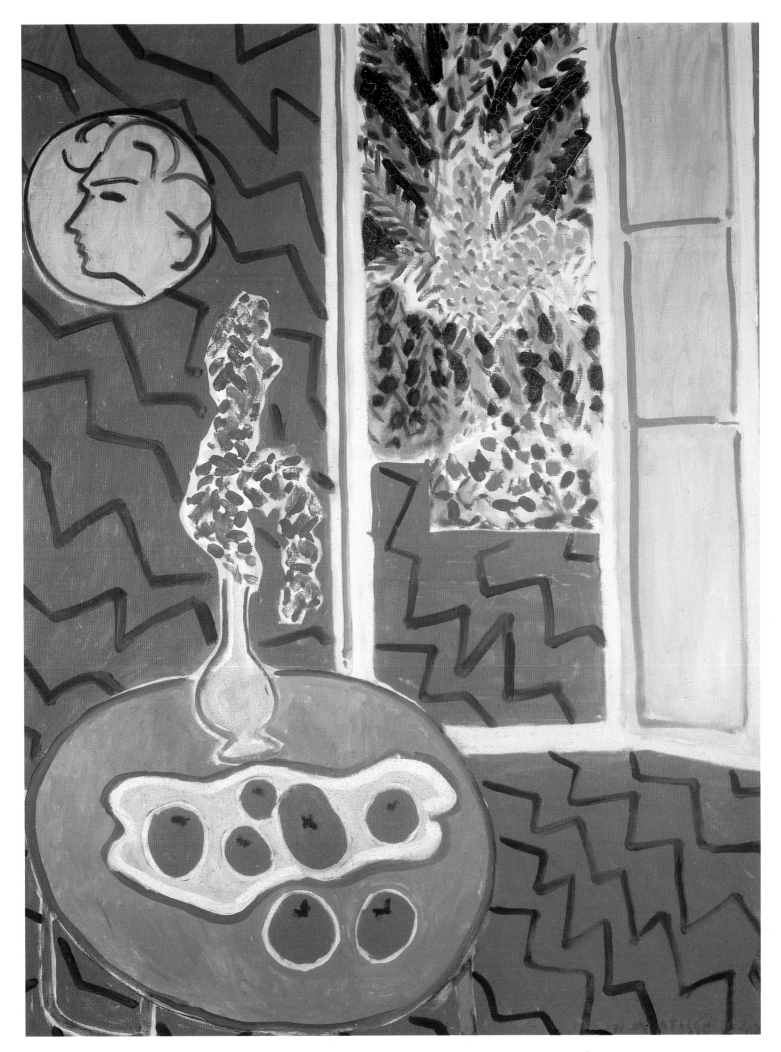

1. Line and Shape

Measuring and comparing proportions

The basic foundations of drawing rely on the ability to judge, compare, trace, and measure essential information to communicate it to the onlooker. The importance of accurate measurement varies with the individual, but it should be looked on as a long-term on-going requirement.

Materials Pencils 2H, HB, 2B upward (H denotes hardness, B softness), kneadable eraser, A3 cartridge paper, newspaper, scissors, straight edge or pencil.

Method

Cut out from paper four basic shapes about 12 inches (30 cm) wide and varying in height. Stick these on a wall or board, starting at the top, in a similar arrangement to that shown (top right). Stand back central to the group and practice how to measure. Practice

measuring from various distances; you will find that the proportions remain the same but sizes differ.

Bird's eye view: Measuring Stand with your shoulders parallel to the wall about four feet away. Extend your arm fully, holding the straight edge, and close one eye to focus both on the wall and the straight edge. Measure with your drawing hand the width of the shape seen. Once the angle coincides with two sides of the shape, use the tip of the straight edge to fix against one side and slide your finger or thumb along the straight edge to fix the other side. After the first shape has been measured, continue measuring to find how many times it divides across. Remember that only width and height can be measured *not* depth.

Sight size: Judging, comparing, increasing and decreasing Sight size is the actual proportions measured from a shape and transferred to paper. Sight size can vary accord-

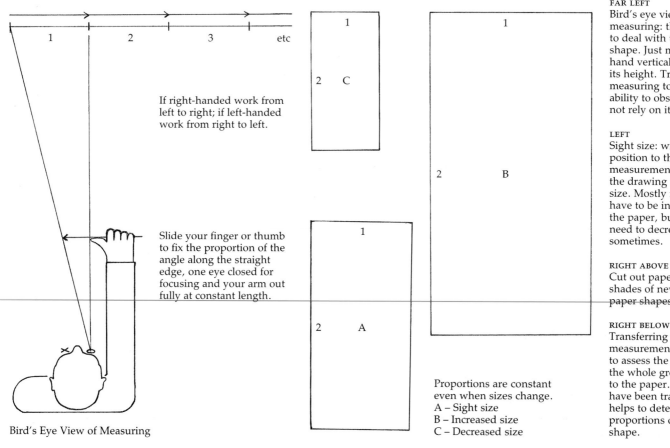

If right-handed work from left to right; if left-handed work from right to left.

Slide your finger or thumb to fix the proportion of the angle along the straight edge, one eye closed for focusing and your arm out fully at constant length.

Bird's Eye View of Measuring

Proportions are constant even when sizes change.
A – Sight size
B – Increased size
C – Decreased size

FAR LEFT
Bird's eye view of measuring: this shows how to deal with the width of a shape. Just move your hand vertically to measure its height. Try to use measuring to improve your ability to observe and do not rely on it completely.

LEFT
Sight size: with a fixed position to the subject, any measurement used direct to the drawing will be sight size. Mostly measurements have to be increased to fit the paper, but you might need to decrease sometimes.

RIGHT ABOVE
Cut out paper: use different shades of newspaper or paper shapes.

RIGHT BELOW
Transferring measurements: it does help to assess the proportions of the whole group in relation to the paper. Once they have been transferred it helps to determine the proportions of the first shape.

Place a group of four cut-out shapes similar to the arrangement shown. Stick the highest shape first.

ing to your distance from the wall. Once two proportions are compared, shorter against longer, they remain constant if the shape is increased or decreased in size. In the same way a slide projected on a screen keeps the same proportions, even when the distance between screen and projector is changed, and angles are constant.

Sight size: Transferring, increasing, tracing Measure and compare width against height of the whole group. With these proportions, transfer the group and increase its size to an A3 paper. Then measure the width of an outer shape in relation to the whole group towards your drawing hand. Transfer and increase these proportions on paper. Do this in relation to height to find the position of the first shape to the whole. Judge the positions of the rest of the group with the help of points of contact (where two shapes meet). Tracing the angles and following through is also helpful.

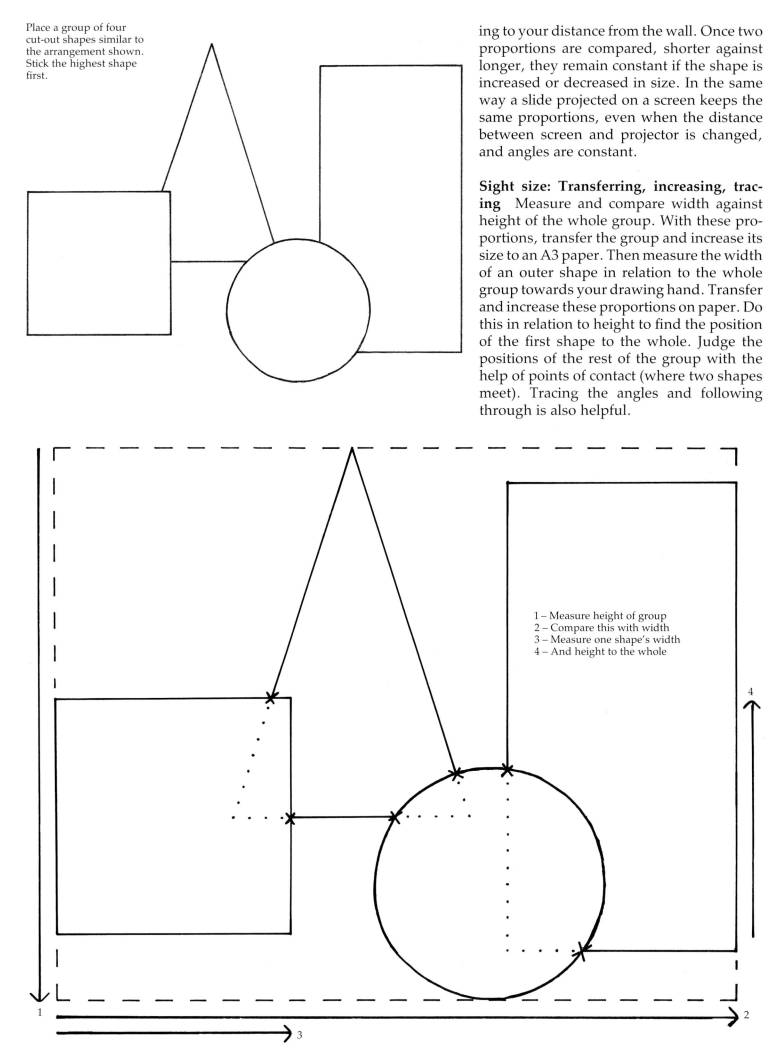

1 – Measure height of group
2 – Compare this with width
3 – Measure one shape's width
4 – And height to the whole

Placing a group

Placing a group of shapes or objects on paper is the first decision to make when drawing and, once determined, is difficult to change. There are a number of ways of achieving accurate placing to suggest depth; this comes through practice and is connected with the positions of spaces between the shapes and the relation of the group as a whole to the background.

Method

Add three more shapes to overlap the existing group at sides and base. Measure the proportions of the group, width to height, and also the middle of group. Transfer the proportions and increase them on A3 paper, keeping more space below the base line. Measure, transfer, and increase the central shape direct from the group and find the equivalent position on the paper where the middle vertical line has been indicated (top right). Add the rest of the shapes with the help of points of contact and negative spaces (areas between the shapes). Assess the levels of shapes in relation to each other in all directions, up and down as well as side to side. Try to keep the space on each side of the group equal, with less space above the highest shape and more space below the lowest shape. The area below the lowest shape is the most vital, as it gives depth to the group as a whole.

Next, try practicing the technique but starting with the shape opposite the drawing hand (if right-handed, start with the left

shape, and if left-handed start with the right shape). Measure, transfer, and increase as before. Finally, instead of using flat shapes, try using simple three-dimensional objects and follow the above points. The objects are best placed against a light background.

Logical placing The lower a shape is placed in a drawing, the nearer to the front it appears. When placing a group, work upward from that shape, which should overlap any shape above it. The same rule applies to the rest of the shapes. By keeping to this rule, you create an illusion of depth, even when flat shapes are used.

Spacing When a rectangle is evenly-spaced on a sheet of paper, it appears to be static. When it has less space below it, the rectangle appears to be dropping. When it has more space below, this gives a sense of depth.

A – Space even around edges, rectangle static.

B – More space above, rectangle advancing.

C – More space below, rectangle receding.

ABOVE
Placing a group: the first decision is to place the dimensions of the full group on the paper with the depth implied.

With the middle of the group and the paper plotted, the central shape can easily be placed. Other options are to start with a shape from the sides of the group.

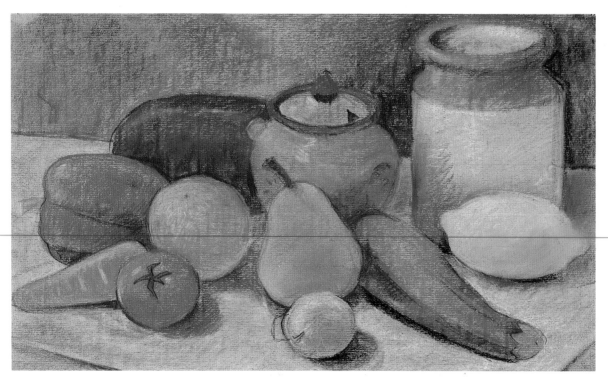

LEFT
This still life in pastel illustrates the importance of placing.

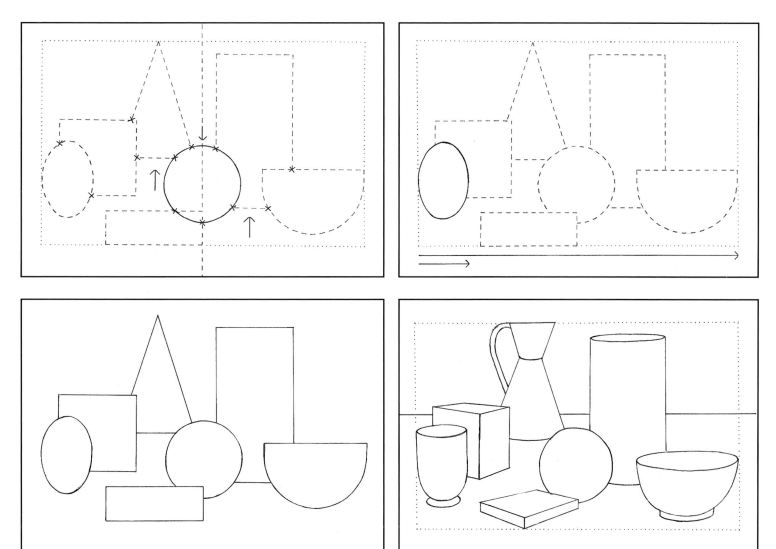

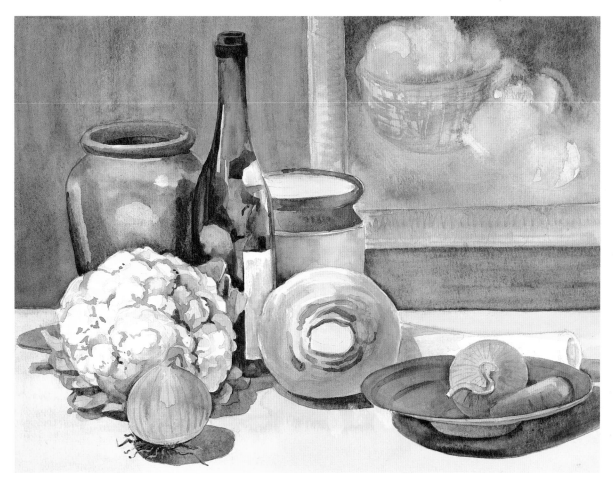

ABOVE
Logical placing: these diagrams show the addition of extra shapes and the effects of logical placing in the layout of the first exercise. The second stage is suggested by the still life of basic forms.

LEFT
Not only does this picture in watercolor stress balance in its design, but also, in the way it is distributed around certain divisions and by a pivot point. See pages 20 and 22.

'The painter is a choreographer of space; he creates a dance of elements, of forms' – Barnett Newman.

Ellipses and Cylinders: The Third Dimension

In order to give convincing structure to cylindrical objects, so that they really look three-dimensional, deceptive illusionism is used to give the onlooker a sense of depth.

Materials Pencils, etc. cylinders/cans.

Method

Put some water in a clear glass. View the top of the glass at eye-level and notice that the water level can be seen as an ellipse, while the base of the glass forms a broader ellipse (see illustration).

Place four cans on top of one another on a flat surface. Bring your eyes level to the half-way point and observe that the ellipses are larger above and below that point.

Drawing an ellipse Draw a rectangle to fit an ellipse, and with horizontal and vertical axis lines cut through the middle sections of the rectangle to make cross-over points which act as guides for the shape of the ellipse.

Conceptual view According to this, the ellipse is larger at the top and smaller at the base, with the middle line shorter than the sides. This is based on our awareness from

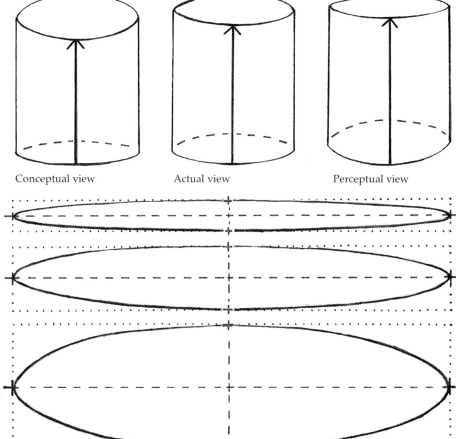

Conceptual view Actual view Perceptual view

Ellipses based on four crosses at half-way points

empirical evidence that the top must be round to drink from and the base must be flat to sit on a table.

Actual view Ellipses are equal at top and base and the middle line is the same size as the sides. This view is based on the way a cylinder is made; it would be impossible to manufacture without an even shape.

Perceptual view In this the ellipse is smaller at the top and larger at the base and the middle line is taller than the sides. This is based on a static viewpoint which maintains that the eye-level is constant and fixed. The perceptual view ties up with the way that ellipses get larger away from eye-level. It coincides with what was seen when viewing the glass of water. It means that this view comes closest to the truth of seeing. The middle line, being taller, will appear nearer for the onlooker.

To create an illusion of form, shapes are distorted to appear like the subject. The actual view is the true one because of its exactness, but artists have used both a perceptual and a conceptual version of the truth in order to give two-dimensional representations a convincing sense of depth and illusion.

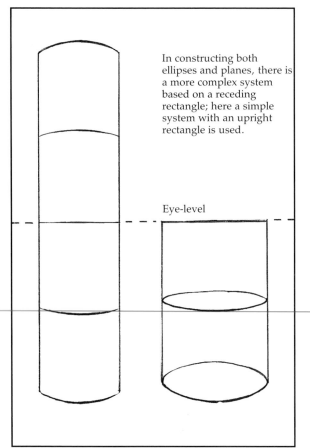

In constructing both ellipses and planes, there is a more complex system based on a receding rectangle; here a simple system with an upright rectangle is used.

Eye-level

LEFT AND ABOVE
These diagrams show how the difference in proportions between the relative height to width of each ellipse can often be distorted by preconceived notions. Once the ratio of proportions, as determined by the eye-level, is recognized, it becomes crucial to a convincing illusion of form.

RIGHT
An imaginative application of ellipses to give contours to cylinders.

'Exactitude is not truth'
– Henri Matisse.

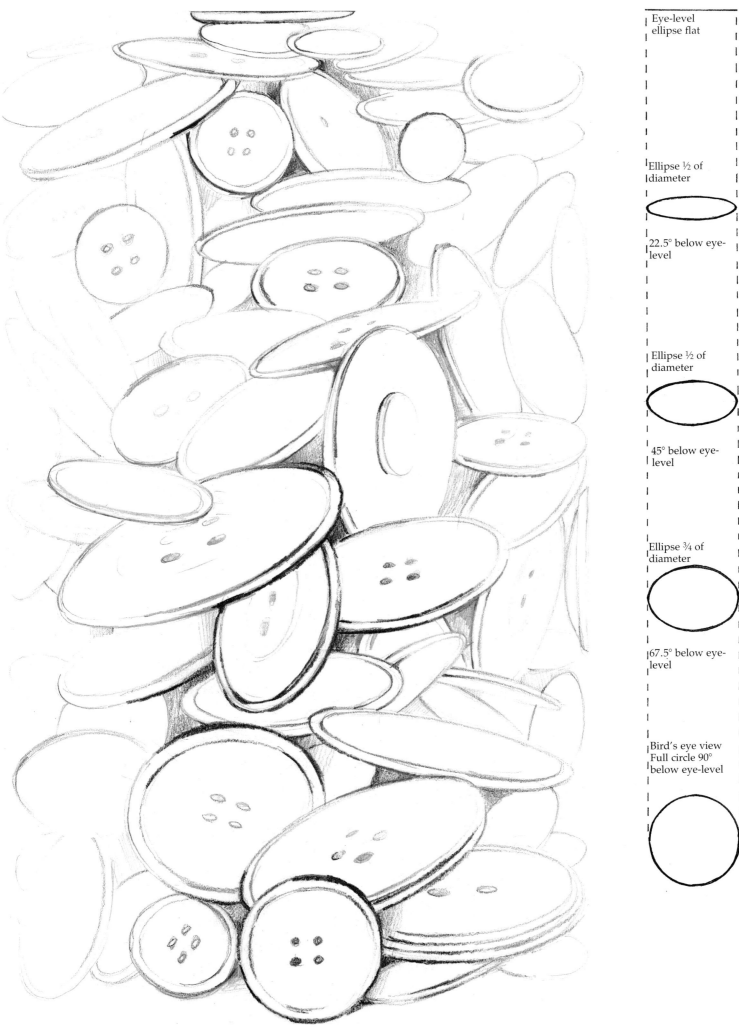

Eye-level
ellipse flat

Ellipse ½ of
diameter

22.5° below eye-
level

Ellipse ½ of
diameter

45° below eye-
level

Ellipse ¾ of
diameter

67.5° below eye-
level

Bird's eye view
Full circle 90°
below eye-level

Perspective: Constructing Planes and Cubes

When an object is observed from a fixed viewpoint and the eye-level is constant, the illusion of form and space is made more convincing if converging lines move away from the position of the onlooker toward a single vanishing point. This is based upon the fixed central viewpoint, which relies on the optical impression that parallel lines converge toward a single point.

Materials Pencils and other drawing materials, cubes/boxes.

Method

Take a box with no lid, and preferably two compartments. Look inside the box with the top at eye-level. Notice that the middle and base planes increase in size away from the top.

Place four boxes on top of one another on a flat surface. Bring your eyes level to the half-way point (level with two boxes). Observe that the planes are larger above and below that point.

Conceptual view The plane is larger at the top and smaller at the base, and the middle line is shorter than the sides. This is based on our awareness, both from empirical evi-

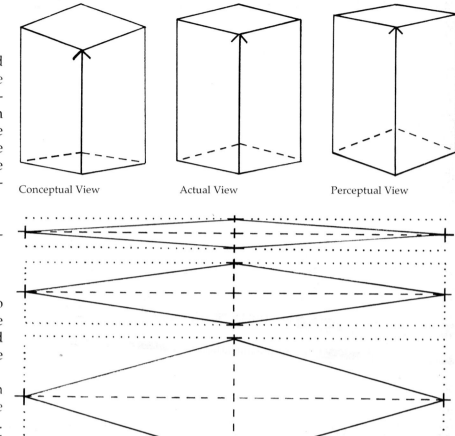

Conceptual View Actual View Perceptual View

Planes based on four crosses at halfway points.

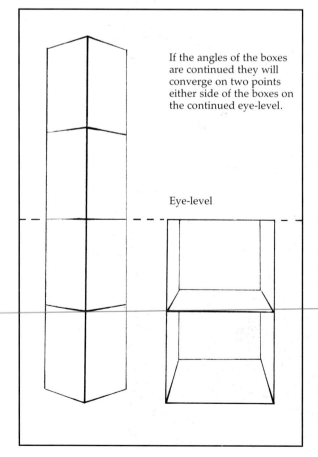

If the angles of the boxes are continued they will converge on two points either side of the boxes on the continued eye-level.

Eye-level

dence and common sense, that to place objects on a box top, the top must be large, and to put a box on the floor, the box must be flat at the base.

Actual view The planes are equal at top and base and the middle line is the same size as the sides. This is based on the way a box is made by machine with equal sides.

Perceptual view The planes are smaller at the top and larger at the base and the middle line is taller than the sides. This is based on a static viewpoint in which the eye-level is fixed and constant. The perceptual view ties up with the way that planes get larger away from the eye-level. Also, it coincides with the evidence observed when viewing the open box. It means that this view comes closest to the truth of seeing. The middle line is taller, so will appear nearer to the onlooker, with angles seeming to converge back from the picture plane to give perspective.

Place a number of tins and boxes at different angles in order to judge their ellipses and planes. Transfer this information to A3 paper, using the measuring and placing techniques on pages 12-13.

ABOVE AND LEFT
These diagrams show how the difference in proportions between the relative height to width of each plane can often be distorted by preconceived notions. Once the ratio of proportions, as determined by the eye-level, is recognized, it becomes crucial to a convincing illusion of form and space.

RIGHT
M C Escher
Tower of Babel 1928
Woodcut
A striking example of perspectival foreshortening as seen from above.

'If you cut out illusion, then painting becomes completely real' – David Hockney.

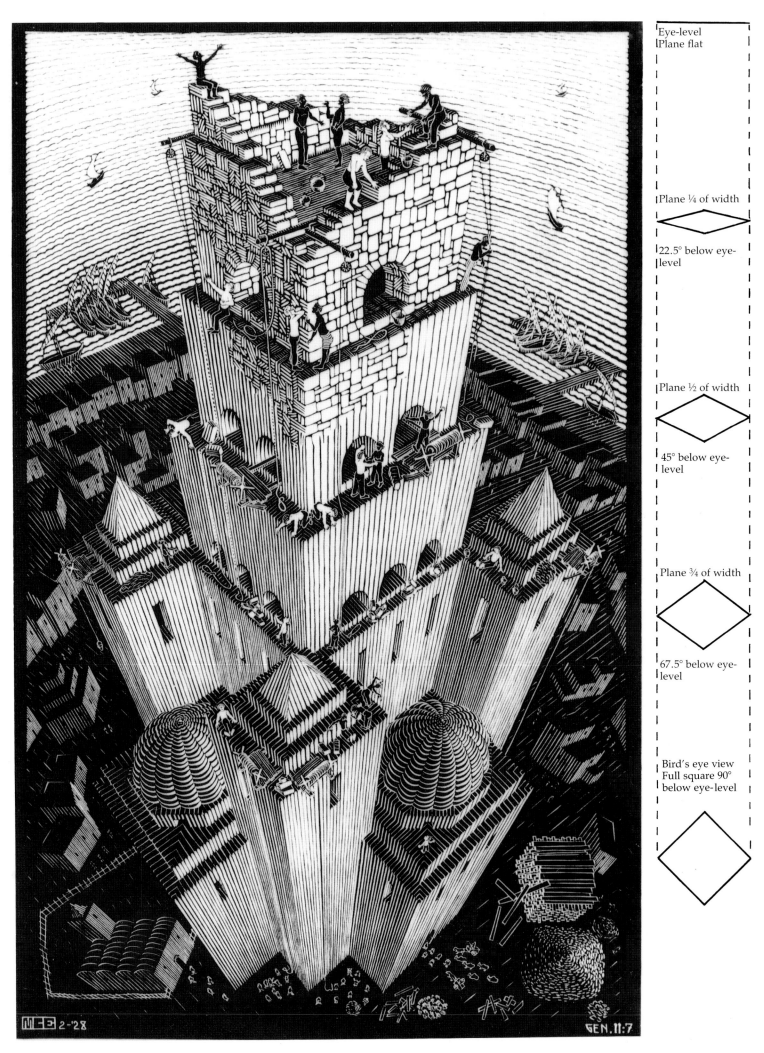

Eye-level
Plane flat

Plane ¼ of width

22.5° below eye-level

Plane ½ of width

45° below eye-level

Plane ¾ of width

67.5° below eye-level

Bird's eye view
Full square 90° below eye-level

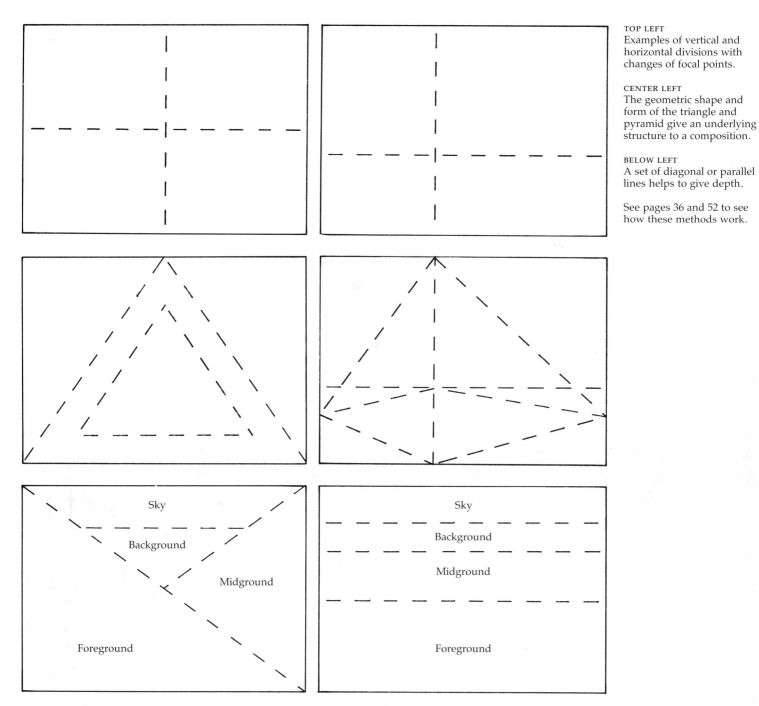

TOP LEFT
Examples of vertical and horizontal divisions with changes of focal points.

CENTER LEFT
The geometric shape and form of the triangle and pyramid give an underlying structure to a composition.

BELOW LEFT
A set of diagonal or parallel lines helps to give depth.

See pages 36 and 52 to see how these methods work.

Composition: Dividing the Picture Plane

The art of composing a picture is dictated by the impulse to organize form and space using different elements and techniques, from contrast to decoration. It is one of the more useful ways of illustrating the development from one style to another; Renaissance to Baroque, Neoclassicism to Romanticism, Cubism to Surrealism, for example.

The diagrams above show a variety of composition techniques based on the division of the picture plane. All the paintings in this book fall into one of these categories.

Materials Pencils and other drawing materials; history of art books to suggest to you the range of possibilities.

Vertical and Horizontal Divisions

The constant divisions of the picture plane are the vertical and horizontal lines; because they do not deviate from the true, they give a firm base for stability and solidity. Even divisions of the picture surface emphasize symmetry, giving exactly equal shapes, and as a result they are repetitive. Moving both the horizontal and the vertical line to the golden section creates a more interesting arrangement and greater possibilities of structural balance and harmony.

The Golden Section

This is based on the division of a line or rectangle into two unequal parts in such a way that the ratio of the smaller to the larger part

equals the ratio of the larger part to the whole. Roughly, 3/8 is to 5/8 as 5/8 is to the whole, and thus the golden section runs in a sequence of 3-5-8-13-21-34, etc. Examples of this ratio can be seen in everyday objects such as books, doors, windows and buildings. The ancient Greeks formulated the system, applying it particularly in their temple buildings, and it still holds true today.

Geometric Forms and Shapes

The use of overlapping and interlocking triangles to organize the picture space gives receding depth, while a number of similar linking shapes of different sizes give harmony to a composition. With the pyramid form, depth is inherent (as with any three-dimensional form) and the sense of a stable foundation is increased by its flat base. Because of the firmness of the triangle and pyramid, there are many examples in still life painting where the base serves as the table top, confirming the usefulness of geometry for structure. This type of composition was frequent in the Italian Renaissance and later periods, as demonstrated by the impressive picture by the young Velasquez (below).

Diagonals and Parallel Lines

In the example shown (far left bottom and below), the first diagonal cuts the frame into two equal halves, with the lower half used as a foreground. The second diagonal just cuts the upper half, to give a midground and background. The larger shape at the front is reduced to mid-sized and smaller shapes; still life objects occupy the front half, allowing a setting behind.

Another way of creating depth by a change in the size of the various grounds is to use a set of parallel lines. The still life in both cases can be dropped to the lower half of the frame and overlap the edge.

BELOW
Diego Velasquez
An Old Woman Cooking Eggs
1618
Oil on canvas,
38¾ × 45½ inches
(99.1 × 116.8 cm)

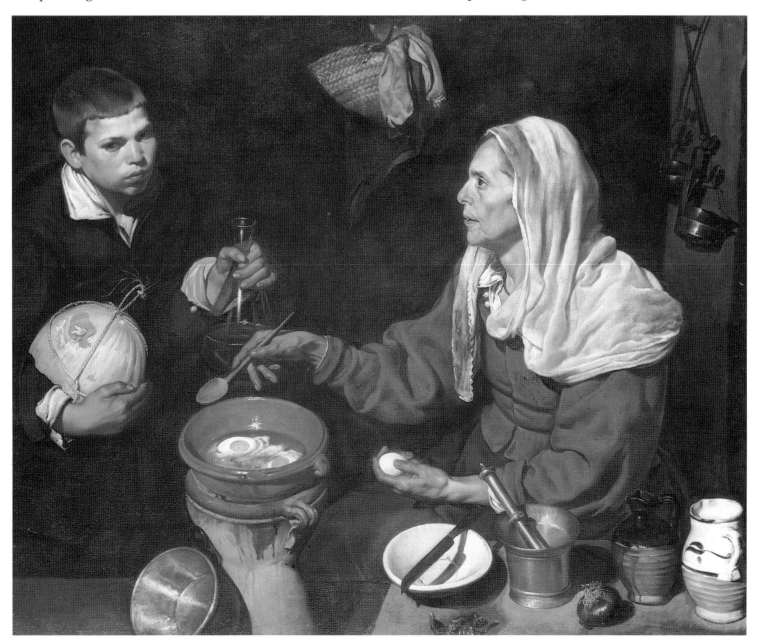

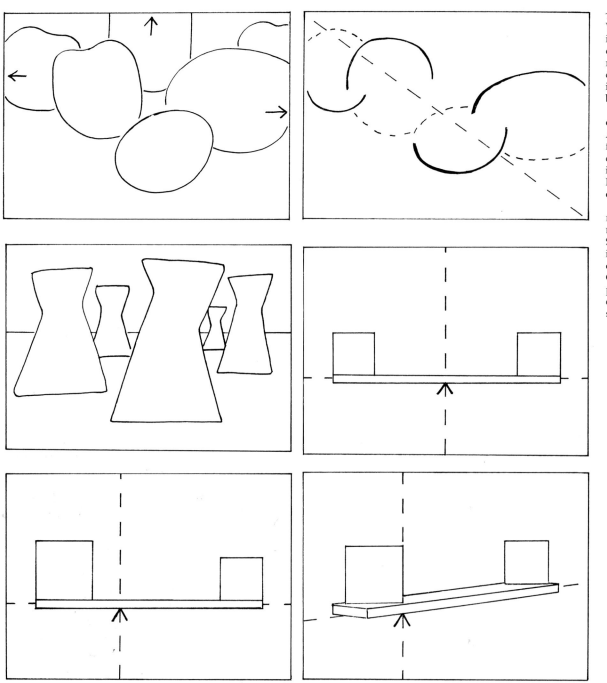

TOP LEFT
When a diagonal is featured
in a picture with
overflowing shapes, the
result is a sense of
continuity, as if the eye is
invited to move around and
beyond the frame.

CENTER FAR LEFT
Among artists who have
found that similar shapes of
different sizes create
interest, Klee, Matisse and
Morandi are obvious
examples.

NEAR LEFT CENTER AND
BELOW LEFT
Setting up a still life
involves balancing shapes,
colors and textures.
Cézanne would take
painstaking steps to place
each object before he
started to paint.

Circles and Curves: Cropping and Interlocking

To give a prominent place to some objects in a still life means overlapping the group, with certain objects having to be cut into or cropped. The general rule is to make contact with the top and sides of the frame but to leave a certain amount of space below the lowest object, allowing an illusion of depth. The possibility of cropping selected shapes, which reduces the negative spaces in the surface area, can be best realized with a cut-out frame. When Japanese prints, with their characteristic cropped figures, were introduced into Europe in the mid-nineteenth century, artists were inspired to crop their own compositions to emulate what they had seen.

Interlocking curves of reversing C shapes, giving flowing serpentine lines, can be applied to a number of different picture structures. They work best interspersed along a diagonal, as shown top right, where they can combine to suggest movement through the rhythm of their lines. These shapes were dominant in Baroque, Rococo and Romantic Art.

Similar Shapes of Different Sizes

Although there are many variations on the types of composition you can choose, there is a useful principle that gives an underlying theme or key to holding component parts together. This maxim is that *similar* shapes of *different* sizes, tones, colors, textures, etc, create interest. Notice the operative words which show where the emphasis lies.

The Balance of Weight – See-Saw and Pivot Point

When two identical shapes are evenly distributed, the result is an exact balance which, in comparison with other arrangements, is predictable and lacks interest. As soon as there is a shift to accommodate a larger shape (see far left below), the pivot moves closer to it, to make a balance which is unpredictable, but more interesting. It is a physical fact that a larger weight can be balanced by a smaller weight on a see-saw when the pivot is nearer to the larger weight.

In pictorial terms, this can be seen objectively and can be better understood when the see-saw is placed parallel to the picture plane. Once the see-saw is moved away and turns into the picture (see near left below), more depth is suggested and further adjustments can be made. This idea can be developed further by changing the shapes into different tones and colors which deal with balance subjectively. Notice how the pivot point moves away from the center when there are no equal shapes.

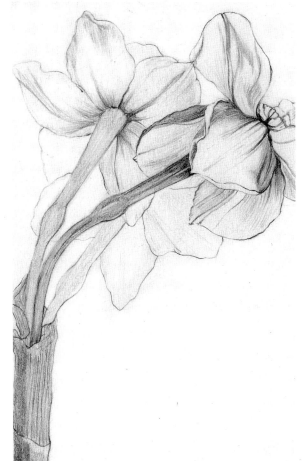

'Composition is the art of arranging in a decorative manner the various elements at the painter's disposal for the expression of his feelings' – Henri Matisse.

LEFT
A delicate pencil study of narcissi.

BELOW
This pastel drawing has utilized the diagonal effect by cropping.

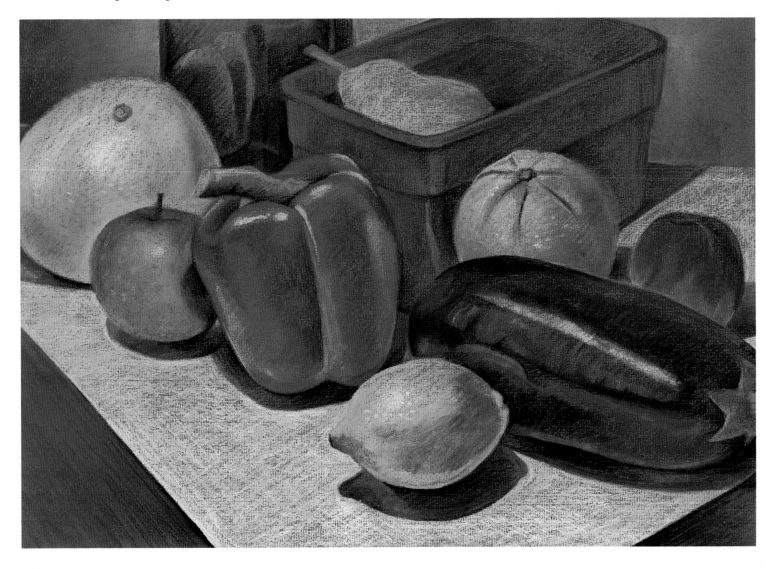

2. Tone

Tonal Gradations

Learning to draw with charcoal and a kneadable eraser serves primarily to discover how the medium can be manipulated to gain certain effects with shading and rubbing out to create an illusion of depth. In this case the charcoal is equivalent to the shade and the eraser to the light; like oils, this is an adjustable medium which accommodates changes of decision. This facility to alter and change what is being drawn is absolutely crucial to a beginner's progress. The use of an eraser in schools of old was tantamount to admitting a lack of drawing ability due to failure of technique. The purpose and function of the eraser here is not to correct mistakes, but rather to further improve the drawing. After all, learning to draw with light as well as shade is the same procedure that occurs in painting with oils.

Materials Charcoal stick (medium), kneadable eraser, soft tissue or stump. Fixative or hair spray, A3 cartridge or layout (bank) paper. Simple three-dimensional forms like apples, grapefruit, pears, etc.

Method

Use a stick of charcoal (medium strength – not too hard or soft); snap a short piece off and set it aside. Sharpen one end of the longer piece on glass/sandpaper to a wedge. Place at least three objects in a group to draw. With the sharpened end, draw in the outlines lightly, looking mainly to the placing of the objects at this early point. Work toward your drawing hand to avoid oversmudging and so that you can see what is being done. Start to shade the objects by blocking in the dark areas with the underside of the wedge shape, using the charcoal in broad sweeps and not picking at the drawing with the tip. If you need to blend the charcoal, use fingers, tissue or the stump to create gradations. For larger areas of the background, use the small piece of charcoal on its side and the tissue to spread it evenly.

LEFT
The first stage is to indicate the shapes of the objects with the minimum of line and detail. At the same time the need for placing, etc, should be observed.

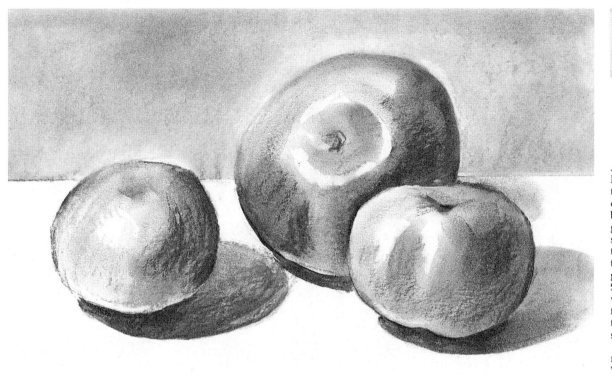

The aim at this stage is to lose the hard outlines in order to suggest the fullness and roundness of the objects. Keep comparing drawing and subject and assessing your progress. Keep the eraser softened so that it can pick out lighter areas. In the final stages you can concentrate on making the form convincing by noting the strength of light and shade, avoiding detail until as late as possible.

When you have finished, use fixative or hair spray to prevent the drawing from smudging too much. Do not spray direct, but from above to fall on to the drawing.

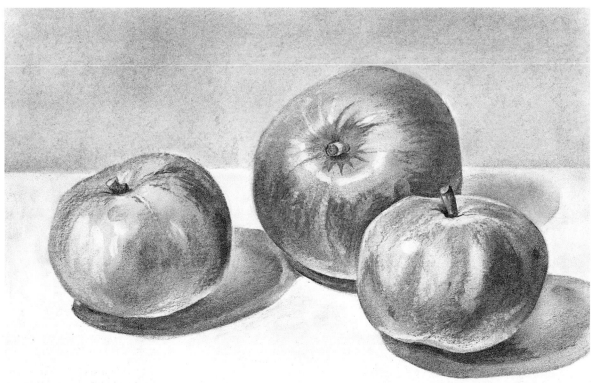

LEFT BELOW
By scrutinizing the form more closely with light and shade, the conviction of solidity increases and is made more 'real' by the concern for detail.

'. . . Painting is no more than tinted drawing' – Jean-Auguste Ingres.

Tonal Values

Tone is to drawing as color is to painting. Looking at Cézanne's watercolors, Van Gogh's pen and ink drawings and Seurat's conté studies, each shows a remarkable similarity to their oil painting. Which came first? Drawing is an obvious foundation for painting and is often the initial means by which an artist gleans the information he needs.

A cone, cube, cylinder and sphere can conveniently demonstrate what happens when a given form is perceived in terms of tonal values. These basic geometric forms, on which most objects are based, can be used as here to show where facets of light and dark appear at their greatest strength relative to the onlooker. When the objects are illuminated from one side, you will see that the lightest and darkest parts are inside the form and not, where they might be expected, on the edges. In each case there is proof of this phenomenon, so it is evident that the lighter and darker part of each object coincide with the point nearest to the onlooker.

Materials Charcoal and other drawing materials. Four basic forms: cone, cube, cylinder, and sphere.

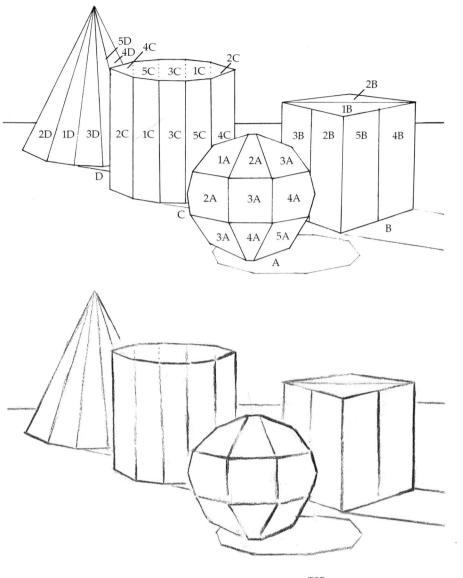

Method

On a practical level, the breakdown of the four objects into flattened planes can help to explain how to analyze the outward form, which is made more complete when volume and solidity are taken into account as well.

The diagram (below) shows how the tonal values of each object have been assessed by numbering the different planes.

In these early stages of learning to draw, it helps to simplify the process into discrete

TOP
If the grades between white and black relate to tone, then tonal values deal with assessing them. This diagram shows how those values can change by weakening from foreground to background.

ABOVE AND LEFT
Once you start drawing from the basic forms, it will help to break them down to flat shapes. In the lower diagram the process of simplifying is explained with the shapes taken into tones.

Light	¼ Tone	½ Tone	¾ Tone	Dark
1 White	2 Light gray	3 Gray	4 Dark gray	5 Black

In every case the lightest and darkest parts of each object (1 and 5) are seen at the nearest point to the onlooker. The effect of this is to give a more convincing rendering of form. The change of tone can take place from object to object.

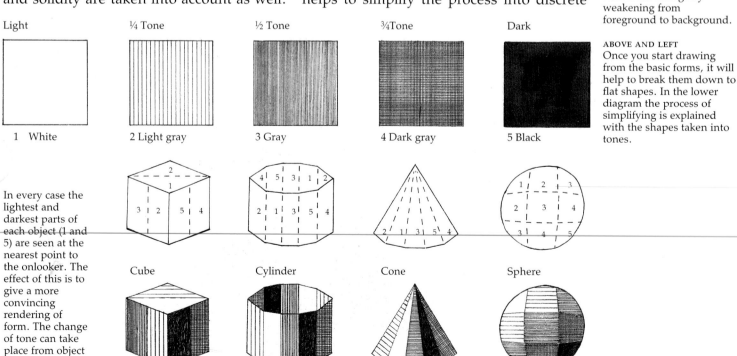

Cube Cylinder Cone Sphere

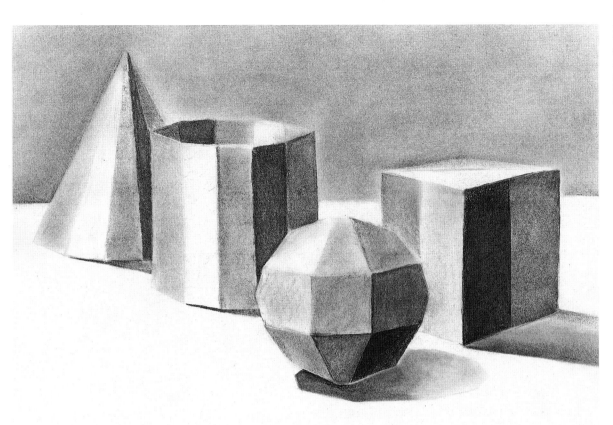

stages and not to tackle anything too difficult at first. Like a trainee juggler, it is best to start with a few things at a time, then, when you have gained confidence handling a few objects, more can be included, step by step and one by one.

With a group of objects set up to form a composition, direct the light source from the side opposite to the drawing hand and observe the tonal values in respect of the whole group. Notice that with each receding object, the light and dark values will appear to weaken toward the background of the composition. Follow the same procedure of measuring, placing, and tonal gradations as before (page 24).

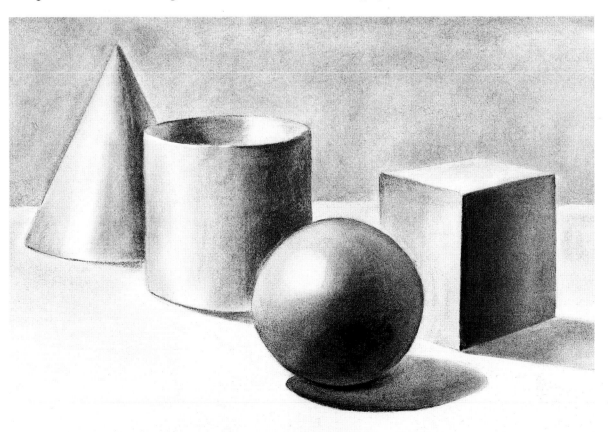

'All forms in nature adhere to the cone, sphere and cylinder' –
Paul Cézanne.

Creating an Illusion of Form

Using cut-out paper (collage) limited to three basic tones makes it difficult to include much detail yet convey a three-dimensional impression. The effect of working with white, gray and black in a sequence of light against dark, light against medium, medium against dark, is instrumental in making decisions about selection. It is not just a question of what to eliminate in the process but more importantly what to include. Thus the benefit of the collage lies in the way it can dictate what is essential, in a restricted use of the medium, and present an illusion of form with flat shapes.

Materials Pencils, etc, white, gray and black paper, scissors, glue, chalk, five objects of graded sizes.

Method

Set up the group of objects with the lowest object at the front and the tallest at the back, making sure that they overlap. Isolate them from the background by placing them on a white drape. Make a line drawing in pencil with self-contained shapes as shown (right), with special regard for changes in tone, allowing reflections and other surface detail as of minor significance. Mark the shapes to indicate the tone selected, with L represent-

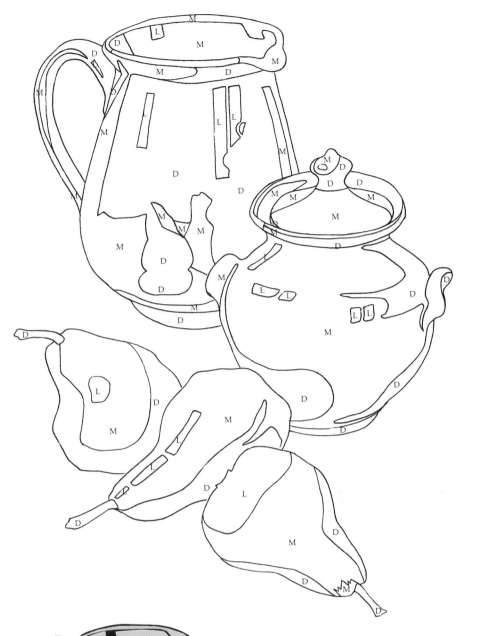

ABOVE AND LEFT
The important thing in this exercise is to plan ahead. For example, make sure that you stick with line only in the first stage and that you indicate the chosen tone.

Remember that it is only the silhouette that needs to be traced on the black paper.

When you come to trace around the gray shapes, keep within the black so that when the shapes are cut out and placed, they are slightly smaller than the drawn shape.

'Once an object has been incorporated in a picture it accepts a new destiny'
– Georges Braque.

ing light, M – medium, D – dark. Once com-
plete, chalk the reverse side of the drawing
in a color which will show up on all three
papers you are going to use – white, gray
and black.

With a hard pencil or ballpoint, trace
around the silhouette of the drawing on
black paper and cut out the shape. Put the
black silhouette on white paper and before
sticking it down, consider the placing and
the spaces around the shape.

Next, on a gray paper trace around the
shapes of the drawing which are within the
medium tones. When tracing the shapes,
make them fall slightly inside the edges of
the black shape. Once the gray shapes have
been cut out, the slightly smaller size will
leave a black outline.

Finally, repeat the same step on white
paper, tracing around light tones, which
should also be traced within the margin of
the black silhouette. This leaves a black out-
line that appears to embrace and marshal the
other shapes.

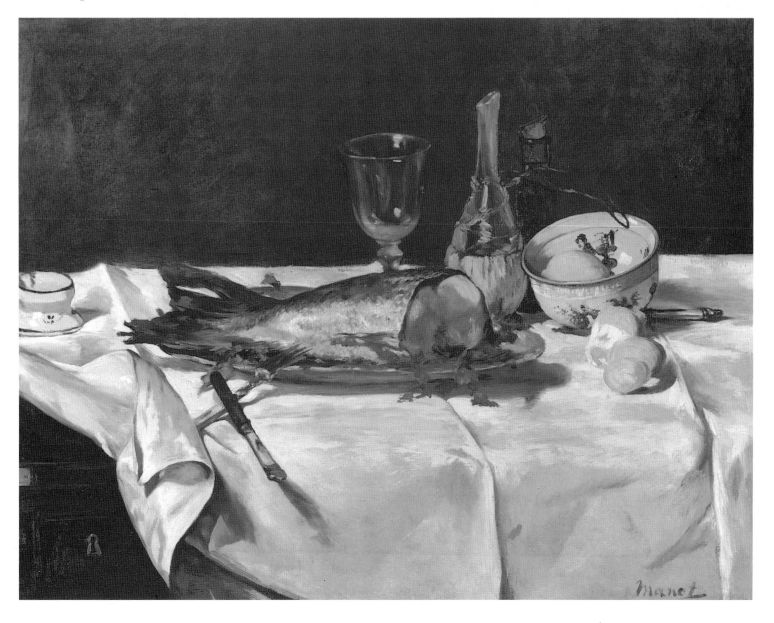

LEFT
It is interesting to see that with flat shapes, rather than graded shades of tone, an illusion of form is apparent. This method can be seen very effectively in posters and print-making, e.g. lino-cuts, lithography, wood-cuts.

BELOW
Edouard Manet
The Salmon c.1868-9
Oil on canvas, 28⅛ × 36⅓ inches (72 × 93 cm)

Tone and Color: Monochrome

The aim here is to mix a given color between white and black, to consider its position tonally between the extremes, and to extend the range of tones from three to nine. A flat surface is an obvious starting point for drawing and painting, and historically has been seen either as a primary feature of the work in its own right, or as a window on reality showing a three-dimensional scene, or as a compromise between the two. From the middle of the nineteenth century onward, the influence of the Japanese print on painters such as Manet, Degas, Monet and Van Gogh, the cloissonnism of Gauguin and Bernard, the posters of Toulouse Lautrec and Bonnard, the decorative quality of Art Nouveau and Symbolism, the patterns of bright color in the Fauvism of Matisse and Derain, all testify to an emphasis on the flatness of the picture plane.

Materials Pencils, etc; A3 cartridge paper; gouache / designer / poster colors: one primary color, black and white; two watercolor brushes, large and small.

Method

To mix a color between white and black, take a given color, red, for example, and determine its tonal position on the chart (far right top) between white and black, which is 5. Spectrum red would be close to 5 on the

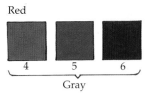

White

1	2	3

White

Red

4	5	6

Gray

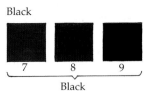

Black

7	8	9

Black

ABOVE
The chosen palette is laid
out to give nine steps from
white to black.

LEFT
The effectiveness of flatness
is again evident in this
work, executed in the
medium of gouache.
 Certain adjustments are
made within the large areas
by moving into other colors
without a change of shape.

tonal chart, spectrum yellow close to 2, and spectrum blue close to 6. Colors like yellow ocher, light red and burnt umber would feature in different positions. On a large palette, or with mixing trays, start to mix the chosen color toward white with equal gradations, then mix with black in equal gradations. It helps when mixing the color with black or white to find the middle tone between the two first, adding the steps in be-tween when the correct mixture is achieved.

Using the same drawing as before, trans-fer it on to A3 cartridge paper and trace around all the shapes. With the sequence of numbers from 1 to 9, and using the drawing and collage as guides, decide which shapes should be numbered 1, 2, 3, for shades of white, 4, 5, 6 for gray, 7, 8, 9 for black. Now fill in the shapes with their appropriate colors, starting from white.

'Remember that a picture, before being a battle horse, a nude woman or some anecdote, is essentially a plane surface covered with paint in a certain arrangement' –
Maurice Denis to the Nabis group.

Tonal Contrast

At this juncture it is worth looking at the difference between an outline and a drawn line. Gaining an outline and losing the drawn line gives form its distinction when producing a drawing with an illusionistic intent, and so it is important to distinguish between the two meanings of line in this context. The simple definition is that a drawn line does not exist in the subject but only in the drawing, whereas an outline is common to both. Other words used instead of outline are boundary, contour, edge, silhouette, border or defining line.

Another aspect of the elimination of the drawn line is conveyed in aerial or atmospheric perspective, whereby more distant objects look paler, which can be best appreciated in landscape art, such as in Claude Lorraine's work. Another example of softened gradations is Leonardo da Vinci's technique, which is called sfumato, while Caravaggio, Rembrandt and Velasquez all composed their pictures with a light/dark contrast of chiaroscuro.

Materials Charcoal, etc, A3 (or larger) cartridge paper. A range of still life objects of contrasting size, shape, form and tone.

Method

On a large surface, place the range of objects you have chosen, starting from the lowest in

the front and stepping up to the tallest in the back, to form a pyramid. Spotlight the group to suit the drawing hand: from the left for right-handed, from the right for left-handed. Referring to previous exercises,

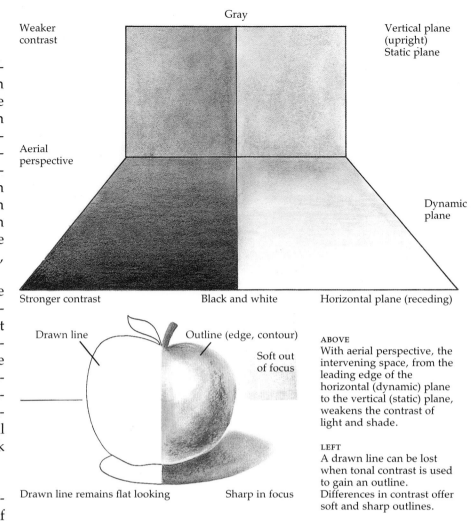

ABOVE
With aerial perspective, the intervening space, from the leading edge of the horizontal (dynamic) plane to the vertical (static) plane, weakens the contrast of light and shade.

LEFT
A drawn line can be lost when tonal contrast is used to gain an outline. Differences in contrast offer soft and sharp outlines.

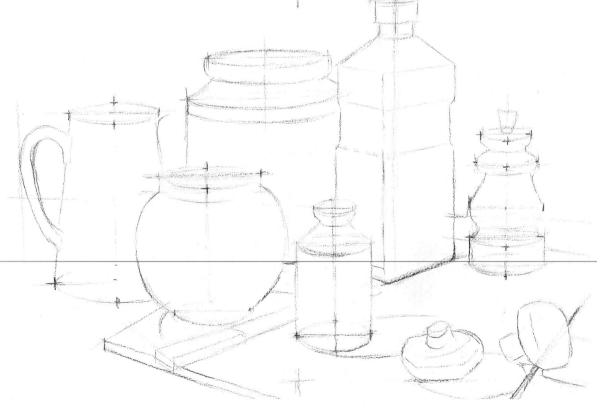

LEFT
This drawing shows how to start with a light touch of line to place and construct the objects, and also gives practice in drawing ellipses.

measure, transfer and increase the proportions of the group on to paper.

Keeping the charcoal sharpened to a wedge and the kneadable eraser softened, follow the procedure as before. The combination of both charcoal and eraser is to maintain soft/sharp outlines, strong/weak contrast of tones, and in focus/out of focus forms. All you should remember is that the more a drawn line is lost, the greater the emphasis given to the outline; losing one retains the other. It is imperative to allow the eye to scan the outlines of each object to determine where the contrast lies.

'Use charcoal, the painter's medium' – W K Wiffen, a pupil of Augustus John, to his students.

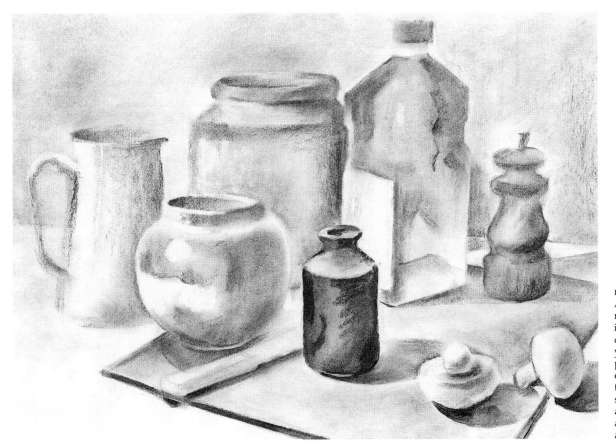

LEFT
As soon as the darks are massed in, there is an immediate feel for the third dimension; remember what you have gained from previous exercises, especially on technique. Try to follow the text as a suggestion of guidelines and not as a directive, and adopt a flexible rather than a dogmatic approach.

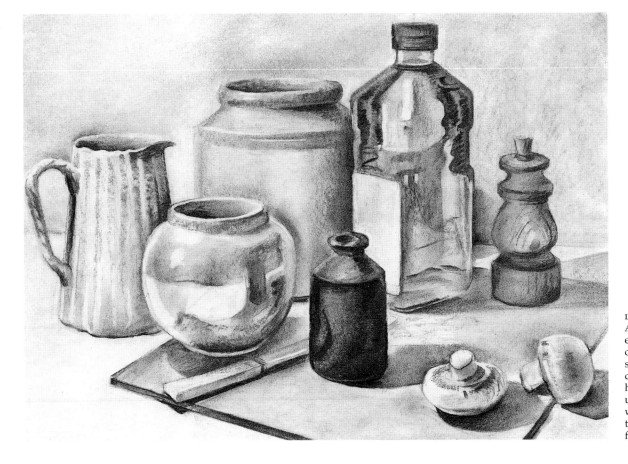

LEFT
Aim to include the fullest explanation of tonal contrast before the final stage deals with the surface detail of the objects. If you have overlooked the underlying structure, there will be a lack of solidity and the still life will tend to be flat looking.

Local Color: The Effects of Light and Shade on Color

Pastel has distinct advantages as a medium for a beginner who is using color in depth for the first time. Because the color is applied with a stick, like charcoal and conté, there is a familiar feel for handling the medium, whereas applying color with a brush requires different skills. Also, instead of using a brush for premixing a color on a palette and laying it down afterwards, then more often than not needing to remix it, pastel allows the mixture of colors to happen on the paper. This means that the experience of mixing and matching color takes place together, with eye and hand working simultaneously, rather than as separate stages. This latter situation can only lead to trial and error; learning about color mixes ends up as a 'hit or miss' process, reducing the possibility of finding a satisfactory match. Here we look at the whole question of color in relation to light and shade, to determine the mixture of grays and a range of colors.

Materials Box of chalk pastels (medium) including yellow, orange, light red, crimson, leaf green, viridian, cobalt blue, ultramarine, burnt umber, violet, black and white or their equivalents. Avoid very soft expensive pastels of tints/shades at this stage. Tone paper, eraser, charcoal and conté.

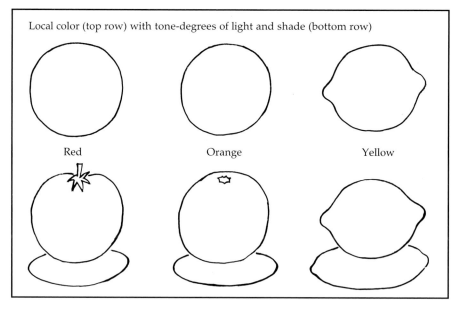

Local color (top row) with tone-degrees of light and shade (bottom row)

Red Orange Yellow

Method

Refer to the mixing chart below. The real, actual, true or local color of a spherical object can be realized in a half-tone without its being changed by light and shade. Once the object is defined in terms of tone, the greater part of its local color, as a flat area, is lost, to be replaced by a three-dimensional effect, which is made more convincing by the addition of a shadow to imply substance. Young children tend to favor using local color instead of tone to describe the visible world, and make little connection between content and form.

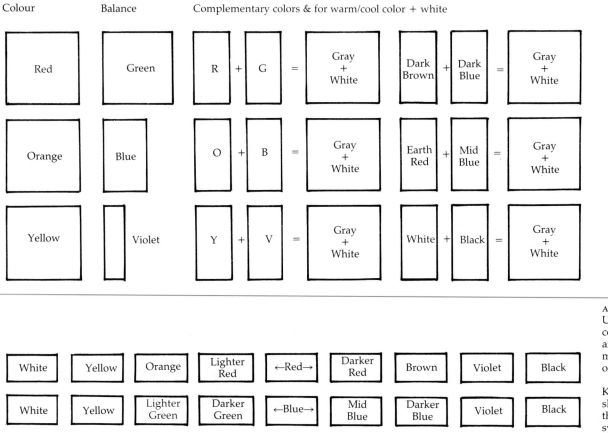

Colour Balance Complementary colors & for warm/cool color + white

Red	Green	R + G =	Gray + White	Dark Brown + Dark Blue =	Gray + White
Orange	Blue	O + B =	Gray + White	Earth Red + Mid Blue =	Gray + White
Yellow	Violet	Y + V =	Gray + White	White + Black =	Gray + White

| White | Yellow | Orange | Lighter Red | ←Red→ | Darker Red | Brown | Violet | Black |
| White | Yellow | Lighter Green | Darker Green | ←Blue→ | Mid Blue | Darker Blue | Violet | Black |

ABOVE AND LEFT
Use the charts in conjunction with one another to relate to the mixing charts on the opposite page.

Keep to the instructions shown and you will find that it is a straightforward system.

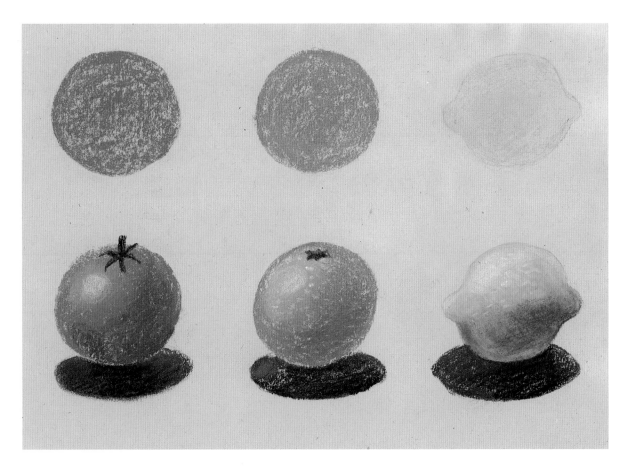

LEFT
Do not apply the pastels too solidly because subsequent layers need some paper surface.

After blocking in the red add green and violet for the darks; add orange, yellow and white to lighten. Once the orange has been done, add blue for the dark; add yellow and white to lighten. When the yellow has been indicated, add violet for the dark; add white to lighten.

For the cast shadows mix the dark brown and blue, with some black to finish.

Mixing grays with complementary colors, as shown in the chart below left, makes use of warm and cool colors to neutralize one another. Gray is a neutral or non-color. A mixture of black and white will give gray, but in monochrome only. The amount of color used for obtaining gray is important and the proportions of the colors should be considered. A color mixed through a range of other colors demonstrates how color can be made lighter and darker without the use of white and black, and these can be reserved and eventually be used for tints and shades.

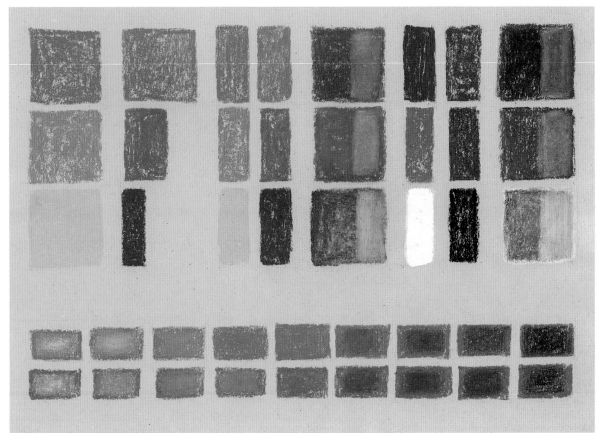

LEFT AND FAR LEFT
There are two columns for mixing grays, one deals with complementaries mixed together and the other with earth colors for mixing grays.

R – Red
O – Orange
Y – Yellow
G – Green
B – Blue
V – Violet

The bottom rows show how the middle color is mixed on both sides, using lighter colors before reaching white and darker colors before reaching black.

Tonal and Tactile Values and Contrasts

The aim here is to compose a picture which relies on various source material, both by direct and indirect means. This is to allow the composition to grow naturally from a single object, observed and drawn first without a group setting, with the composition completed by separate additions. Logical placing and the use of a diagonal are relied on as compositional devices. With the emphasis on natural forms being viewed from close-up, surface texture and detail become important. A thumbnail sketch would be useful as a preparatory measure.

Materials Black and white conté sticks (bistre (brown) and sanguine (red) can also be used), eraser, tone paper, charcoal, natural forms.

Method

Choose three compatible objects of different size, tone and texture, e.g. cone, horse chestnut and its shell; shell, pebble and driftwood; bone, fungus and stone, etc. Take the object which is most interesting in structure and texture and isolate it on a white sheet of paper to view it close up. Hold the object in your hand to study it for tactile sense. On the tone paper lightly indicate with charcoal a diagonal and the placing of the first shape, allowing it the largest

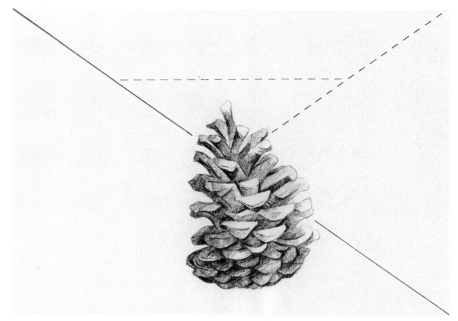

space of all the eventual shapes by making it overlap the diagonal and positioning it toward the base. Once the position is decided, use the tip of a conté stick, sharpened like a pencil, to confirm the shape and add the structure. Start to block in with the sharpened edge of the conté and gradually confirm the form.

Using the same object, but from a different angle and scale, lightly indicate it as a medium-sized shape with charcoal in the same way and complete the form with conté. Add a third smaller shape from the two other objects and repeat them as different sizes as necessary to fill out the lower

ABOVE
Take time to draw the first natural form, making it the largest. Get the feel for the conté crayon before committing yourself; try it out on a separate piece of paper.

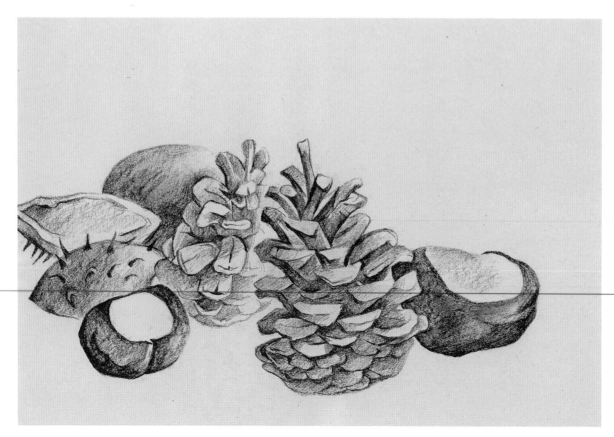

LEFT
The attendant natural forms now in place are less dominant, and so less defined the further they recede.

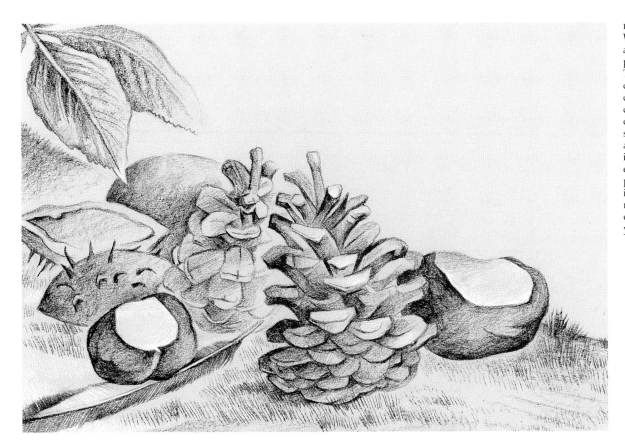

LEFT AND LEFT BELOW
With the lower diagonal almost complete, the picture gradually unfolds. Throughout the development of the drawing there should be a degree of free play in choosing where things should be placed. As long as the rule of logical placing is applied, you can experiment with the placings. Similarly feel free in experimenting with the medium to discover and exploit its qualities to suit you.

half, with the diagonal as a guide and logical placing dictating the positions of the additional shapes.

If you want to link the corners in, use other overhanging shapes or link them from the side or from below. Begin to introduce the light with white conté (without mixing with the black to obtain grays) to give texture to the underlying surface chosen.

Use photographic references for additional animate forms, e.g. insect and landscape, and use the effect of aerial perspective to give receding blocks of softened tones, adding a third dimension to your picture. Scale is another way of giving depth by the contrast of sizes: the small object in the front looking large, the large object in the background looking small.

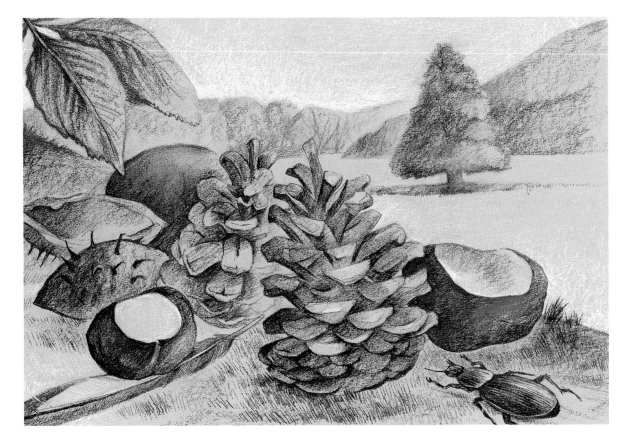

The Effects of Light and Shade on Color

Again using the medium of pastel, this sequence covers mixing colors without initially using white and black, using lighter and darker colors instead into local color, seeing how a combination of related colors creates certain effects, and working into a common color for both light and dark areas.

Materials Pastel, etc, tone paper, fruit, vegetables and toys to test the range of pastels.

Method

Follow the guidelines already given for setting up a group, measuring, placing and so on. In order to work without confining the medium, use the device of cropping to come inside the group as well as working on a larger scale. Starting with charcoal, lightly indicate the outlines of the objects only, with an awareness for composition. It is pointless to do a lot of outlining or detail, as the pastels will be blocked in over the surface.

Use the sides of small pieces of pastel snapped off each stick. The first stage is to skate over the surface of the paper, so that the texture of the paper picks up the medium, occasionally using fingers, tissue or stump to blend. Having dealt with the shapes of the still life, now look closely for the local color by scrutinizing the halftones of each object. Work diagonally toward your drawing hand to avoid over-smudging. Do not cover the paper with a complete pastel layer but allow room for other layers to cling to the paper; pastel does not stick or soak into the surface like other media, but is held by the tooth or grain of the paper. Even when fixed, it needs to be framed under glass to prevent the fragile medium from brushing off or fading in strong light.

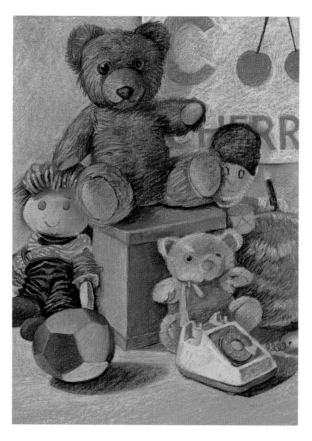

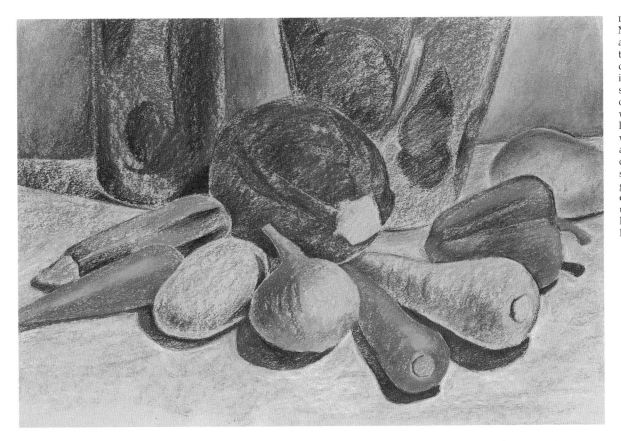

LEFT AND LEFT BELOW
Make use of the natural
ability of pastel to show on
the grain of the paper. This
can exclude a lot of
information which is not
suitable to the application
of the medium when used
with small pieces. It is not
like a pencil or a brush
where a fine point can
achieve fine detail. The
other way to exploit the
suggestive quality of its
grainy effect is by
expressing it in an
understated manner. Pastel
has an affinity to oils, as
Degas demonstrated.

With the local colors indicated, you can now introduce the darker colors (without using black), including the cast shadows. Where possible use the complementary colors to achieve chromatic grays and a combination of dark colors to obtain various shades. Next, bring into play the lighter colors in a similar way, and only use white where it is part of a local color.

To increase the definition in smaller areas, use the tip of the pastel in hatching strokes. The white and black pastels can be used for the strong accents of light and dark, with the final emphasis added with touches of conté crayon. Like charcoal, pastel can be used broadly, in a gestural way, as, for example, in the work of Degas, who raised the technique of pastel to the level of oil painting.

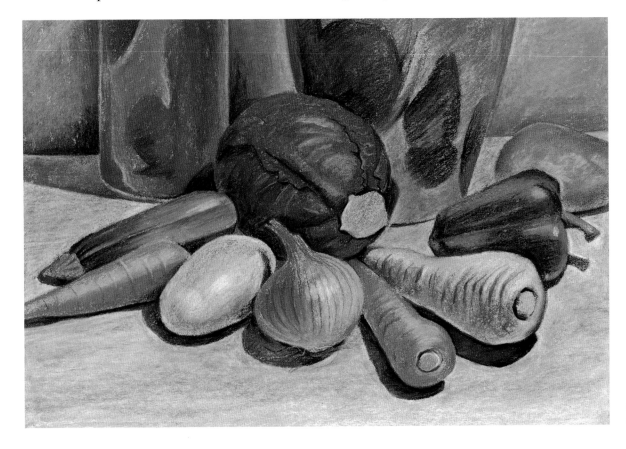

'To color is to pursue drawing in greater depth' – Edgar Degas.

Tone and Texture

One definition of texture is to describe it as the fourth dimension, which adds further conviction to our comprehension of the visible and physical world. Yet the underlying structure of objects has a substance which is essential to form, whereas texture, which shares its space, is merely coincidental because it only covers the surface. Thus form with substance is essential, and texture without substance is coincidental.

Just the same, texture can give an identity to an object which makes it more interesting, for it reaches beyond visual appeal and arouses a tactile sense. When studying texture, it helps to have a range of objects which offer different tactile values and contrasts, such as smooth/coarse, spiky/fluffy, pitted/bubbly. Using various marks with the medium chosen, it is possible to offer many ways to suggest texture, including a textured paper surface with a tooth or grain, e.g. 'sugar' paper. Van Gogh often preferred a coarse canvas with an impasto of oils, giving strong evidence of surface texture.

Materials Charcoal and other drawing materials, white chalk, tone paper. Objects of varied textures – bread and board, wicker basket, eggs and shells, glazed/unglazed pottery, linen tablecloth, lemon, etc.

Method

Set up a group of objects with a textured drape for background and a smooth white paper for a table top. Starting from the back of the group, place the tallest object, which eventually should be off-center, and in diminishing order of height place the rest of the objects toward the front. Avoid regimenting the objects in line; stagger them and close up the gaps between, making sure that the objects overlap and do not touch one another from the chosen viewpoint.

Using charcoal, tone paper and chalk means that at the starting point you have the three basic tones of black, gray and white. Follow the usual procedure established in other drawings, but once the charcoal has been completed with the use of the kneadable eraser, that is the point to introduce the white chalk. The main consideration at this stage is to remember *not* to mix the charcoal and chalk together for grays, but to keep them separate. Obtain the variations of gray by using them with the paper; to make a lighter gray add white, and to make darker gray add black. Keep the texture on hold until the form has been defined.

RIGHT
Textured paper is used here to produce a variety of textures. The three preliminary stages of the drawing demonstrate how to deal with the areas of shadow first, next with the introduction of white to give substance, and finally with exploring the textural content of the still life to give more tangible evidence of the appearance of things.

BELOW
An example of conté crayon in black and white on tone paper.

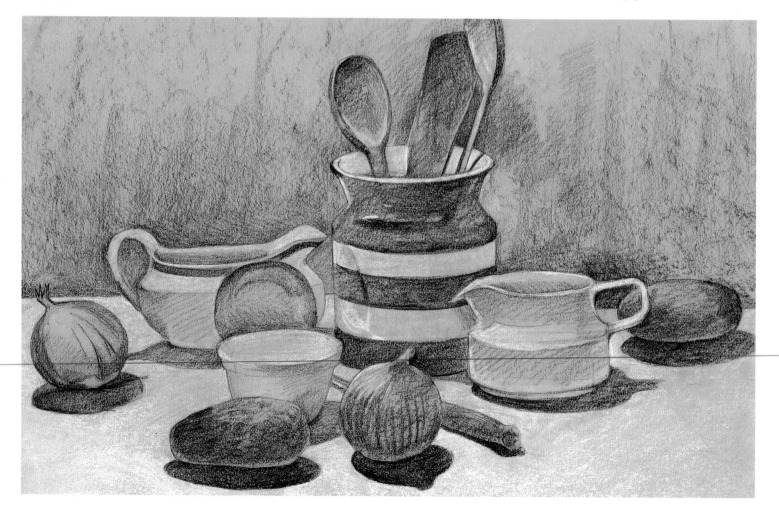

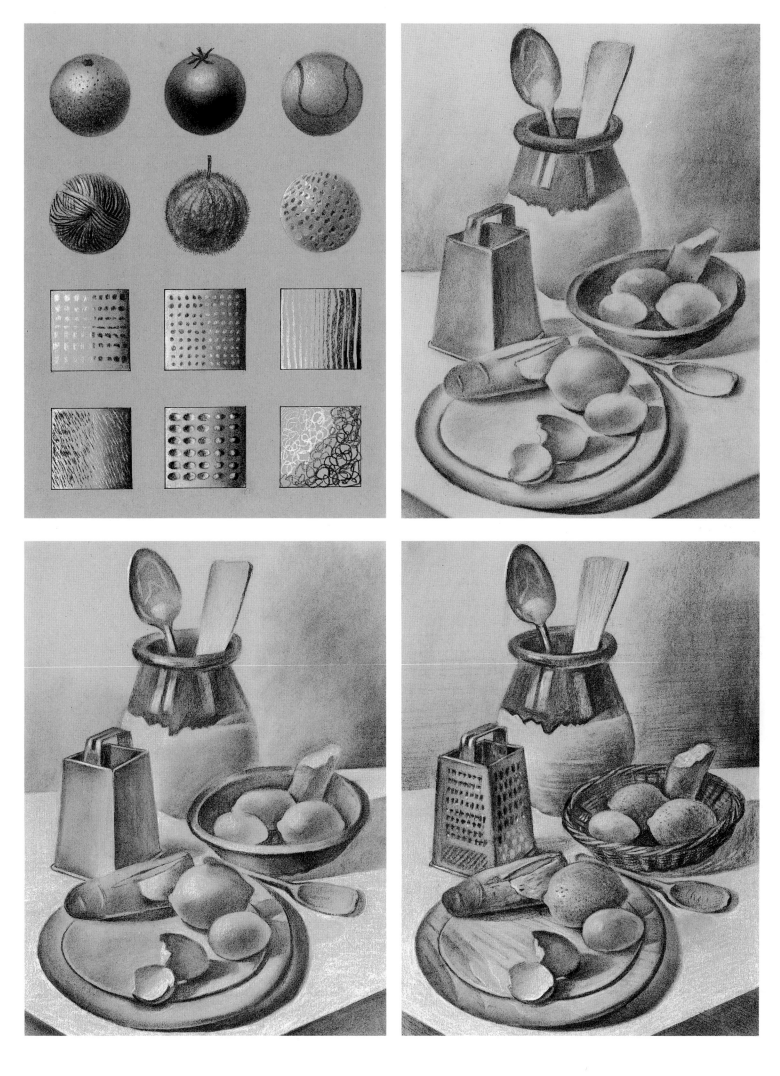

3. Line, Shape and Tone

A Boundary Line: Positive and Negative Space

Paying greater attention to the precise outlines of shapes helps to improve your accuracy in all techniques. The importance of the outline has its equivalent in map-making, where any inaccuracies may have disastrous consequences. Defining the shape of a country with an accurate boundary line, for example, involves using the surrounding countries as a guide. In drawing the equivalent to this is the figure and ground relationship, in which the positive shape (figure) dominates the perception of form, and the negative space behind (ground) is overlooked. It is important, however, to be aware that the same shape can be both positive and negative. This relationship is significant in giving an impression of space, solidity or three-dimensionality to the composition.

Understanding how to use the boundary line can spill over into everyday observation as things seen against one another: trees against the sky, people sitting against windows, objects stacked against a wall.

Materials Pencils, etc., ballpoint or pen, A3 cartridge paper, plants, flowers, furniture, still life objects.

Method

Place a potted plant, a vase of flowers or other still life objects against the light, either with a light source coming from behind, or in front of a window. Indicate a grid system on the window or use a squared-up piece of white paper as the background; one gives a strong silhouette and the other a network of lines for the subject to be seen against. Ignore as much of the pot or vase as possible, and concentrate on the gaps, the negative space, left in between the leaves; with the help of a cut-out frame, select how far to extend the drawing.

Using a hard pencil, start from a large negative shape and trace its outline, making a mark at each point of contact. It is a matter then of carefully plotting each additional

shape around this and working away from it, taking each shape in turn. Keep a check on their relative positions, using points of contact and the grid system as a constant reference source. Use some softer pencils as well and rely on the intuitive ability of eye to hand co-ordination to give accurate assessments.

The value of an objective approach in gathering precise and accurate information lies in clearly defining the parameters of form and space, which in turn contributes to a greater perception of the whole.

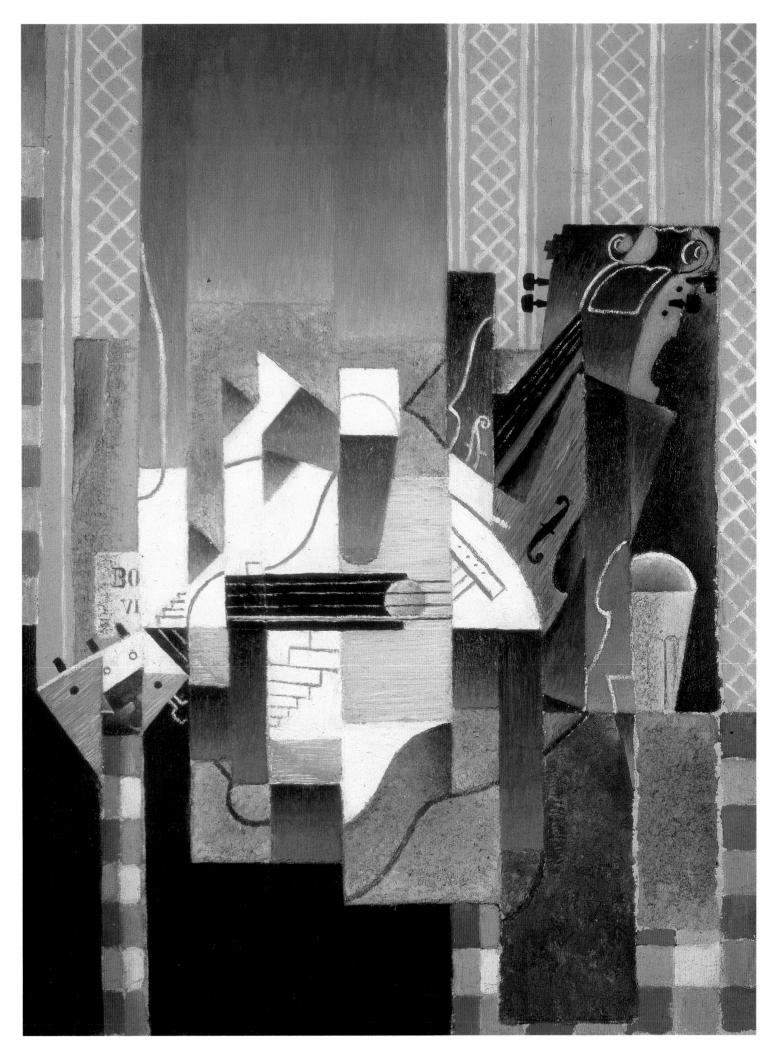

Organic Form: Variation and Consistency in Line and Tone

Depicting organic form requires very accurate line, with some increase of tone and a surface concern for texture and detail. The choice of organic form as subject matter extends your range into natural growth, which often represents a chaos of flowing lines and intricate shapes. To confront this amount of detail demands drawing techniques that combine a precise and controled use of a graphic line for some areas, a loose and liberated use of shading for other parts, with open use of large empty spaces for sparse information.

Materials Pencils, etc, A3 cartridge paper. Plant, to be drawn either in situ or worked from in the studio.

Method

Any botanical type of study relies on a close-up view of the subject to allow you to depict texture and detail, but it is still imperative to maintain form and space as the underlying structure of the composition.

Choose the size of paper to work on, remembering that one of the objectives is to use large areas of white paper, so give the drawing breathing space. With a hard pencil, draw in the main shapes, lightly and quickly indicating them without any attention for detail, so that the starting point can be precisely located in relation to the rest of the paper. It is then a question of working from one section to another, with some layout of guidelines to serve as a kind of scaffolding on which to build up the definition, and using a range of pencils from hard to soft. Keep the pencils sharpened at all times. In manipulating the medium, you can rely on the way pressure on the pencil adds a variable line. Using the kneadable eraser to adjust the strength of line can also help to sort out the accurate placing of shapes by allowing guidelines to be drawn in first and then rubbed out. It can also cut into dark areas, which should be brought into the drawing with a less restricted technique, but contrasted by freer use of the pencil. Concentrating around a focal point to give a summary of the whole enables the rest of the drawing to trail off into empty white spaces.

BELOW
Learning precise control of your pencil is an essential preliminary to the depiction of organic form.

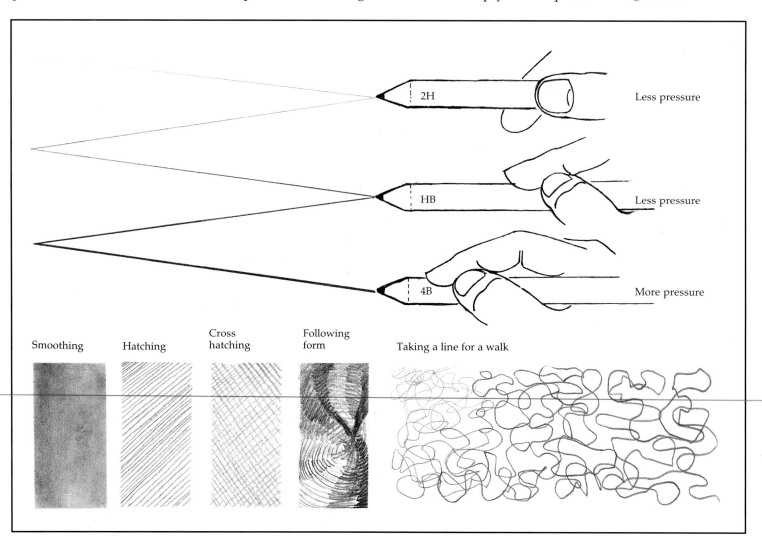

2H Less pressure

HB Less pressure

4B More pressure

Smoothing Hatching Cross hatching Following form Taking a line for a walk

'An active line on a walk moving freely without a goal. A walk for walk's sake' – Paul Klee in his Pedagogical Sketchbook.

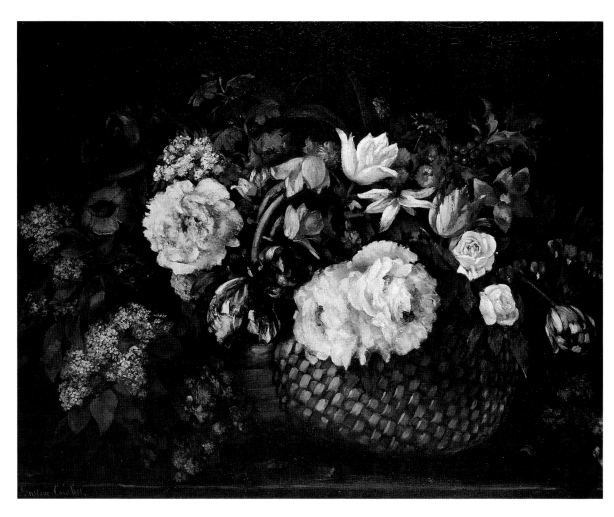

LEFT
Gustave Courbet
Basket of Flowers
Oil on canvas
Courbet was one of the greatest exponents of still life in the mid-nineteenth century.

BELOW
In this drawing, the range of the medium of pencil combines a high degree of finish and lots of detail with the use of the white paper to indicate minimal information. This can be useful in creating a focal point where the study is highly finished and begins to trail away from that area.

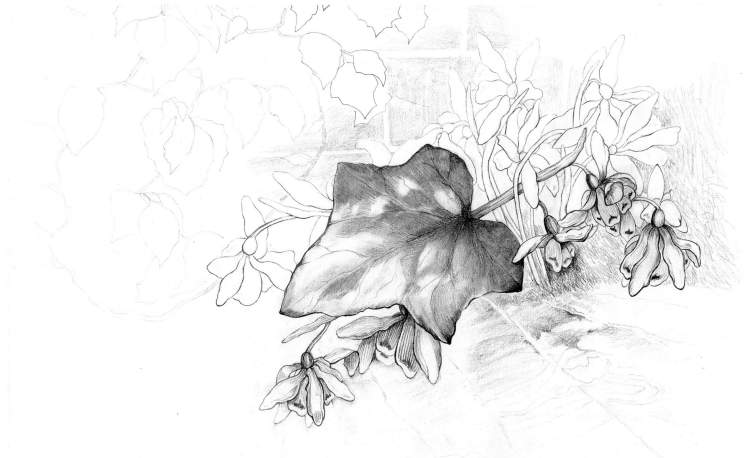

Separating Form and Space

The discussion on pages 42-43 of the boundary line as the demarcation between positive and negative space showed the importance of an accurate and objective approach, but without subjecting the boundary line as such to any scrutiny. The separating of shapes from each other with a line leads on to the separation of form from space with a more demanding line.

The purpose here in using a clear glass container for the contents of the still life is to show that, by conveying their form, the drawing also conveys the space they are contained in, without necessarily and consciously having to draw the container: a case of using economy of line to guarantee that the maximum can be obtained from the minimum.

The other important aim here is to develop a variety of line by using various grades of pencils with the kneadable eraser, which can quickly distinguish form from space. Extend this technique for use in your sketchbook work.

Materials Pencils, etc., A3 cartridge paper, still life objects in a clear glass container, such as dried fruit, nuts, candies, buttons, nuts and bolts, pasta, cones, shells, beans or a mixture of these.

Method

Tilt the container and wedge it at the front to get the best angle to see the objects. Notice that where the objects are seen directly through the glass, at the front, they appear to have a sharper outline, yet where the wider angles of the sides are viewed, the objects seem to have a softer outline.

Based on this direct observation and your objective analysis of the contents of the jar, the evidence of a changing emphasis of outline is provided by the soft/sharp and weak/strong variability of line. Use the guidelines outlined on the previous pages to help. Add some shading to indicate the strongest tonal contrast and a degree of depth and, where necessary, reduce the strength of line with a kneadable eraser.

'. . . There are things which ten hundred brush strokes cannot depict, but which can be captured by a few simple strokes if they are right. That is truly giving expression to the invisible' – Taken from a book of Chinese art theory.

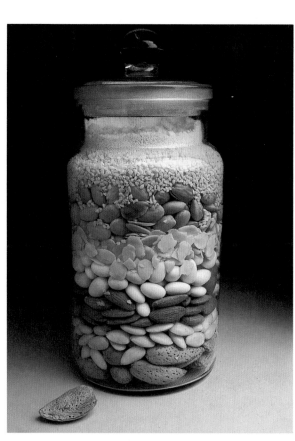

LEFT, BELOW AND RIGHT As the photograph above shows, the edges of shapes stored inside a glass container are less sharp toward the sides of the container. This fact has been used as the main theme in the two pencil drawings.

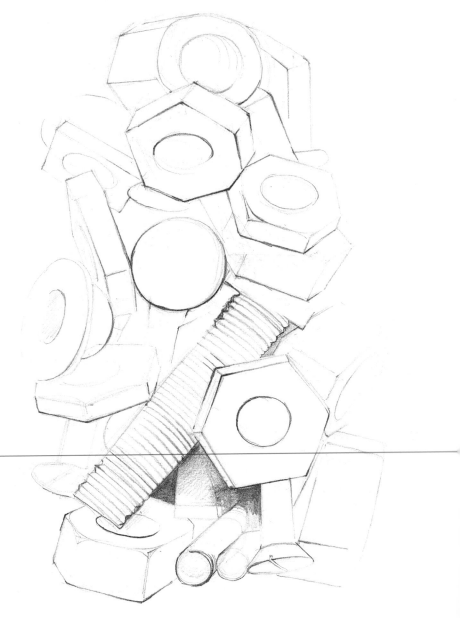

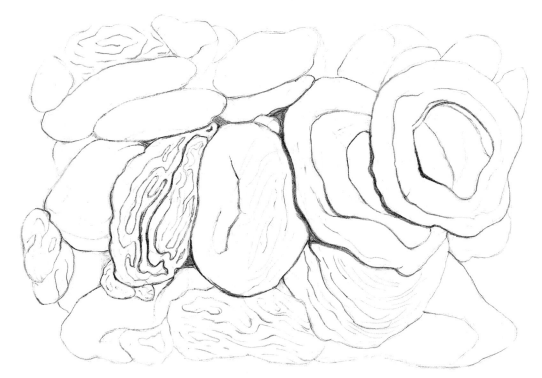

BELOW
Giorgio Morandi
Still Life 1946
Oil on canvas

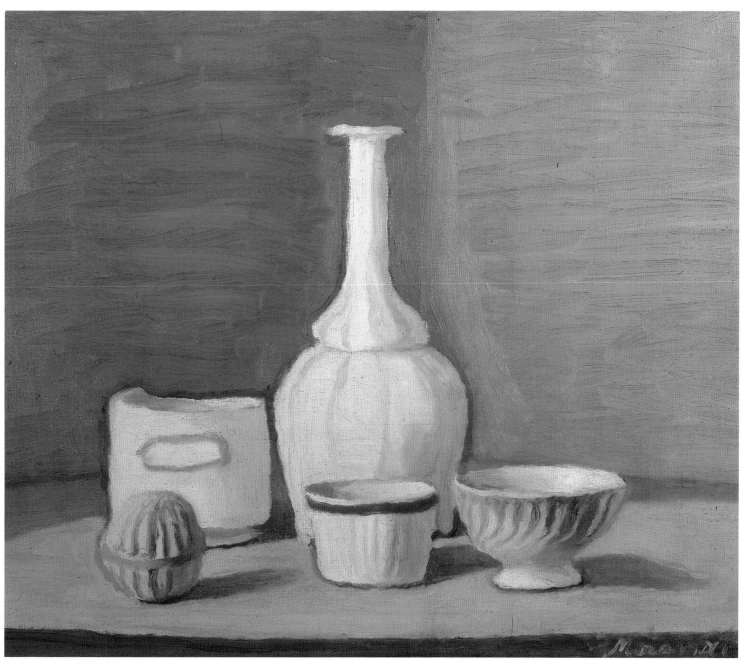

Reflections: Revealing Form and Space by Other Means

Most of the time, creating an illusion of the third dimension is based on direct observation from the souce material, but sometimes it is a valuable experience to work indirectly from a still life. Looking at the objects in a group through reflections produces an interesting exercise and will involve more time on the drawing than usual. This is because it brings in many guidelines from previous exercises to help in the stages of the work, as well as being a more long-drawn-out process. Tone is given maximum use here, with a minimum of line, and includes areas of white paper.

Materials Pencils, etc., A3 cartridge paper or larger. Still life objects, bowls, pots, pans, dishes, jars, mirrors and other objects which are able to reflect well.

Method

Highly reflective surfaces are required if the full effect is to be achieved. Spend some time setting up the position of the still life group in front of the reflecting surfaces, so that the individual objects do not overlap too much and a reasonable view is possible. Some tilting and raising may be needed before arriving at a satisfactory arrangement. Try to have at least two different surfaces to reflect back, with further convex and concave shapes giving the possibility of different viewpoints. With pencil, position the outlines of the objects so that they spill over into the sides and top of your drawing space, allowing some white paper below. Concentrate on the areas of reflection, and combine some of the previous points considered into developing the drawing.

Use the techniques of smudging, rubbing, hatching, cross-hatching and scribbling, with the help of the eraser, to shape the objects and find the correct tonal values. Emphasize the line by varying its tension, strength, precision and weakness. Consider the line as free-flowing, intuitive, automatic and gestural. Keep your pencils sharpened and eraser softened, and continually compare the drawing to the subject. This last point is important to consider in relation to the whole development of the drawing: keep everything going at the same rate of progress by bringing all your subject matter into play as soon as possible.

The final consideration is when to finish. One possible way is to allow the drawing to show the various stages of the process, from plotting out to finished detail, with the white paper playing a part. It is the audience who make the decision in the end by filling in the missing gaps, so never underestimate their intelligence.

BELOW
Rita Hodson
Copper Kettle 1989
Watercolor

RIGHT
This is another example of how the format has been dictated by a tall object, in this case drawing up other objects through its reflections, which also act to reveal form and space by other means.

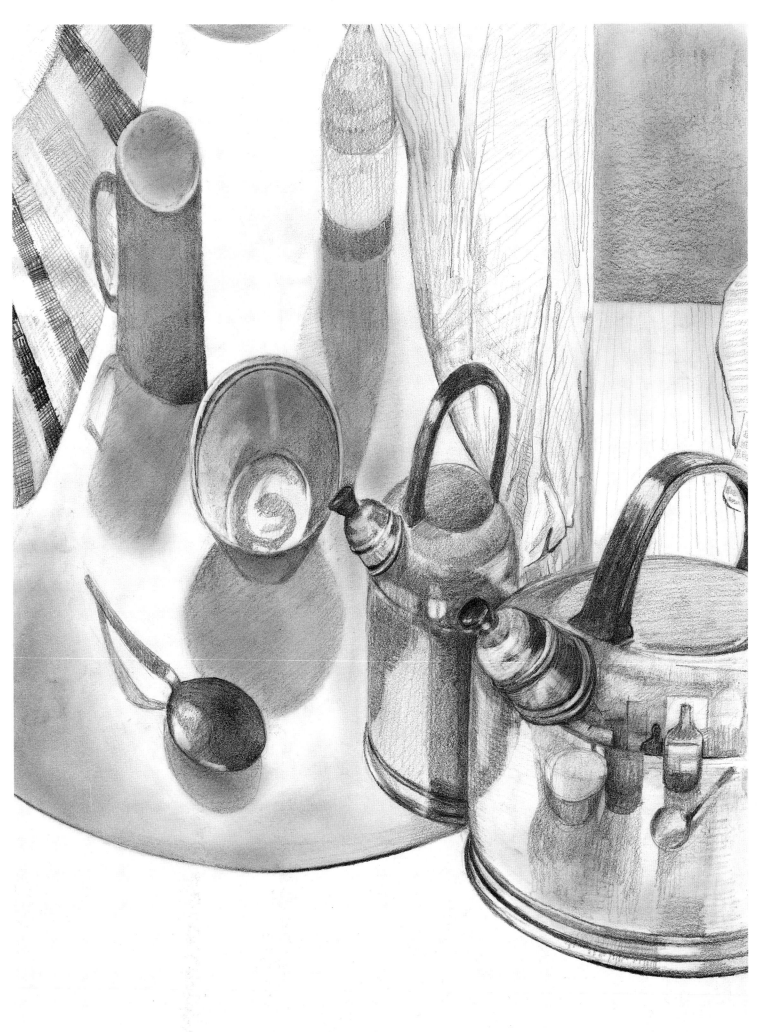

Using Pen and Wash

To handle a pen skilfully demands a confidence which comes through much practice, but where it becomes subsidiary to tone, the quality of line is not that crucial. This exercise offers an opportunity to improve your ability to use pen and ink, which can then be developed into a tonal drawing.

Materials Water soluble (non-permanent) pens, fine/small and medium, large and small watercolor brushes, A3 cartridge paper, still life objects – soft or small fruit such as strawberries, raspberries, blueberries or other berries and cherries.

Method

Taking as your subject small objects which contain a certain amount of detail, draw outlines with a 2H pencil to give thin guidelines which should take in the need for measuring, placing, etc. Use the fine pen to draw in the shapes and, starting from the background with a broken line, come forward into the objects. Take note of the tonal contrast: where there is the greatest difference between light and shade, produce a

'Technique changes but art remains the same' – Claude Monet.

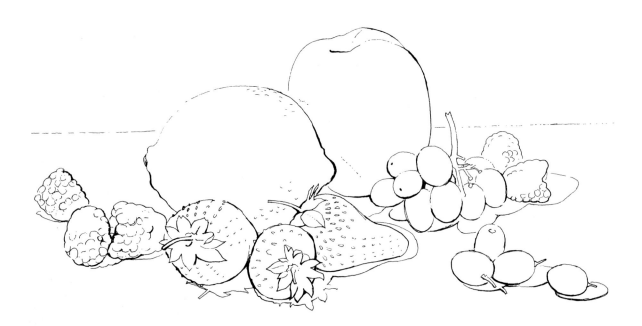

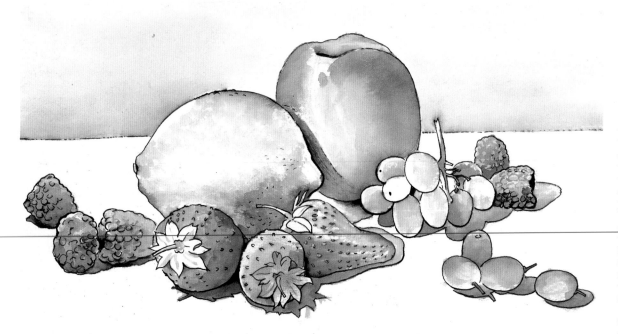

LEFT
The combination of consistency of flow and variable line provided by water soluble pens has opened up the potential of pen and wash techniques. These pens allow instant change and are suitable for working outdoors in the landscape. Waterproof pens also represent an accessible medium for the beginner wishing to venture into pen and ink or wash.
 Before their introduction to the market, artists had to make do with scratchy pens, forever needing to be dipped into a messy bottle of ink.

thicker/darker line toward the front, with a thinner/lighter line toward the back where there is least difference between light and shade. With the cast shadows and any dark areas use some hatching, and avoid putting lines around soft areas of shading which can be achieved with a brush. The linework should only be applied where there are obvious sharp edges; where there are soft edges, rely on the wash.

Once the linework is finished, use a large brush dipped into clean water to work away from the broken lines into the nearer areas of contrast. Instantly the drawing moves into tone; it is soon apparent that the ink disperses in water, but the strength of the line is not affected and remains intact. By taking ink from the tip of the medium pen with the brush, more wash can be obtained, but generally it is safer to draw in with more line. This is a particularly useful technique for sketchbook work.

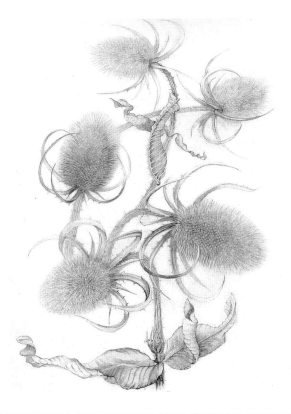

LEFT
The texture of the teasels offers a challenge in drawing their delicacy and intricacy, and pencil seems to be the appropriate means for fulfilling these needs.

BELOW
Claude Monet
Pears and Grapes 1880
Oil on canvas, 25¼ × 31½ inches (65 × 81 cm)

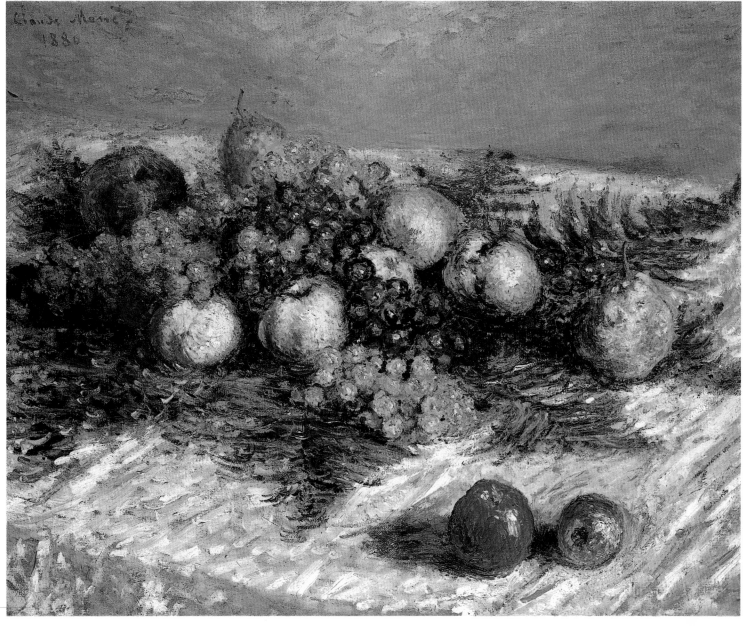

Mixed Media: Transparent Washes with Opaque White and Black

Here we take the medium of pen and wash a step further with a more involved composition combining black and white conté. The composition is based on a set of parallel lines to divide it into receding planes, with a still life of natural forms fitting into this framework.

Materials Water soluble pens, black and white conté, tone paper, still life of natural forms.

Method

Place the natural forms on a large sheet of white paper, with the larger objects toward the front receding to smaller ones behind, and lay them parallel to the long edge of the paper. The choice of objects should include a variety of sizes, textures, forms and tones, with a coherent theme of seaside, woodland or pond, for example, arranged to suggest an actual setting.

Take a position parallel to the objects,

close to the group and showing it in layers, picking a vantage point that also allows the further objects to be seen just above the line of the front ones. The eventual aim of the drawing is to suggest a representative sample of a much larger range of natural forms found in situ, with the setting to be included. Working on a half-tone paper, follow the stages of the previous exercise until the point where the brush has been used, without any further darks being laid in. Before doing any more work on the objects, consider the ground surrounding the objects, which coincides with the white paper. Choose what texture would be suitable, for example sand, pebble, shingle, gravel, dry mud. Draw into those surrounding areas, with room to accommodate some animate form, maybe a crab, and use the brush to give contrast and texture.

The background can be dealt with as flat diminishing layers of soft washes, running parallel with the objects as an aerial perspective sequence and without any detail. Use photographic sources for reference for any additional features. Finally, use the conté crayon in the dark and light areas, particularly toward the front.

ABOVE AND RIGHT
These examples of composing with a set of parallel lines also show the usefulness of tone paper to help in broadening the tonal range. The resulting economy of execution suggests the maximum by exploiting the minimum, in such a way that the paper plays a part.

Colored Lines and Wash

Working out-of-doors with natural light presents new challenges. Opportunities for still life *'en plein air'* might include a barbeque, outdoor café, picnic, garden center, or any activity that includes outdoor equipment, such as fishing, hiking and camping. It is important to experience a direct light in the open air for it gives another aspect to picture-making, and in this case still life. The more freely executed technique is suited to this type of work.

Plein air painting is linked above all with Impressionism, but was taken up much earlier by eighteenth-century landscape painters, particularly Constable and Turner. In the early nineteenth century Camille Corot visited Italy and produced a remarkable series of informal, clearly lit landscapes. Among the impressionists themselves, Monet and Renoir were perhaps the most fervent exponents of the *plein air* traidition.

Materials Depending on the season, this drawing could be done in situ, on the patio, in the garden or wherever. Put together a number of potted plants and flowers as in a hanging basket (or choose a part of the gar-

den), so that there is a compact arrangement of foliage, blooms and leaves, with some trailing down to an open ground consisting of brick path, grass lawn, stone patio, gravel track, peat or soil bed.

Method

Water soluble pens in different colors can be used as in the previous exercise, so follow the initial guidelines. Try to match the local colors using the range of pens but leaving the black to the end. Where the white paper is to be retained, mask it out with a clear wax candle or masking fluid.

With a drawing done under natural light, there is a time limit before the sun moves position to give an entirely different illumination. Aim to work freely and quickly; the fluidity of the medium will assist this process. Once the transparent washes have been achieved with the water-laden brush, to give the main suggestions of color distribution, fill in the dark areas with both a water-soluble and a waterproof black, using the former for shaded blacks and the other for solid blacks. Use correction fluid to bring back any white. Try using oil pastels, which are soluble in white spirit, on white paper in a similar way.

'In painting, as in music, one should look for suggestion rather than for description' – Paul Gauguin.

BELOW
Camille Corot
The Hay Cart c.1860
Oil on canvas
Carot's naturalist clearly lit early landscape work anticipated the Impressionist achievement, although his later landscapes were more romantically blurred.

RIGHT
This is another technique that would be ideally suited for outdoor work; perhaps combined with the water soluble pens discussed on the previous page.

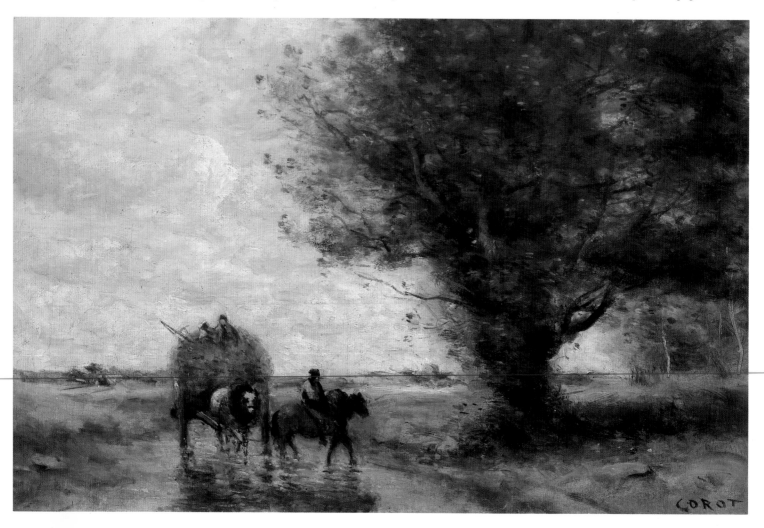

4. Color and Tone

Transparent Washes

The pure technique of watercolor is based on flat transparent washes with no body color or opaque white; instead the white paper is used on its own or for giving luminosity to the layers of tone and color. Gaining command of and confidence in watercolor is based on achieving a degree of control (allowing for happy accidents) over the first and succeeding washes; large brushes are vital to exploit the process. A number of simple exercises in two colors and monochrome are outlined here to develop your skills.

Materials Box of watercolors, tubes or pans or mixture of both, depending on personal preference, to include:

Set 1: Raw sienna, burnt umber, french ultramarine

Set 2: Gamboge, light red (or burnt sienna), viridian

Set 3: Cadmium yellow (deep), alizarin crimson, cobalt blue

Set 4: Lemon yellow, vermilion (or cadmium red), cerulean blue or their equivalents

Two large and two small brushes of a soft synthetic bristle with fine point (do *not* buy sable, they are extremely expensive), heavy-duty watercolor paper, pencils, etc, tissue, sponge, still life of plain kitchen utensils.

Method

Choose a yellow and a red from any of the four sets of colors and, referring to the series of diagrams (above right) follow the four sections in turn.

Separating a wash One of the first things to learn when painting with watercolor is how to keep washes separate from one another and not to allow them to run together when they are applied wet against one another. This is achieved by simply

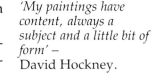

'My paintings have content, always a subject and a little bit of form' – David Hockney.

LEFT
This watercolor uses one color (monochrome) to extend into tone. This means that you can concentrate on the technique and not be distracted or intimidated by a range of colors. Try a number of exercises until you feel confident to move on to color.

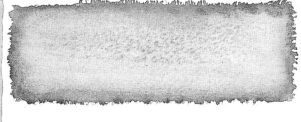

FAR LEFT
Separating a Wash
Draw four simple still life shapes and divide the surrounding areas. Using a yellow and a red, mix a range of tones between them. Starting with the lightest tone, lay in successive washes while they remain wet and separate them with the paper.

LEFT
Laying in a Wash
Allow for three separated shapes on your paper. In the first soak the paper, using a brush with clean water, then lay in the red to see the effect. Dampen the second shape with a sponge and lay in the red. Repeat the red on the remaining dry surface.

FAR LEFT
Blending a Wash
Divide the paper into halves and lay in a yellow wash in one of them. Quickly lay in a red wash to cover half and watch how it blends. With the other section, having laid in a yellow wash to dry, place a red wash and with clean water blend with a brush.

LEFT
Extending a Wash
Take your largest brush and let it soak the maximum red wash. On a dry surface see how far you can spread the wash evenly without resorting to dipping in to more wash.

leaving a white margin of paper between the washes as you lay them in.

Laying in a wash The next step is to discover what happens when laying in a wash into a wet surface (using a brush to soak the paper beyond the area of the wash); a damp surface (using a sponge to dampen the paper); and a dry surface.

Blending a wash When a wash is laid into another wash, wet into wet, the lower wash bleeds into the top one and blends through from the bottom layer. When a wash is applied on to a dry wash and needs to be blended, a clean wet brush will blend it downward from the top layer.

Extending a wash Load the brush as fully as possible and lay in the wash as far as it will extend without loading the brush again. This is one way of preventing patchiness and shows the usefulness of large brushes for spreading the wash.

Try washes in monochrome, using a dark color with three basic tones of light, medium and dark by following the procedure as described on pages 62-63 for increasing your palette to nine colors. Use simple monochrome objects to work with.

'There is neither line nor modelling, there is only contrast. Once the colors are at their richest, the form will be at its fullest' –
Paul Cézanne.

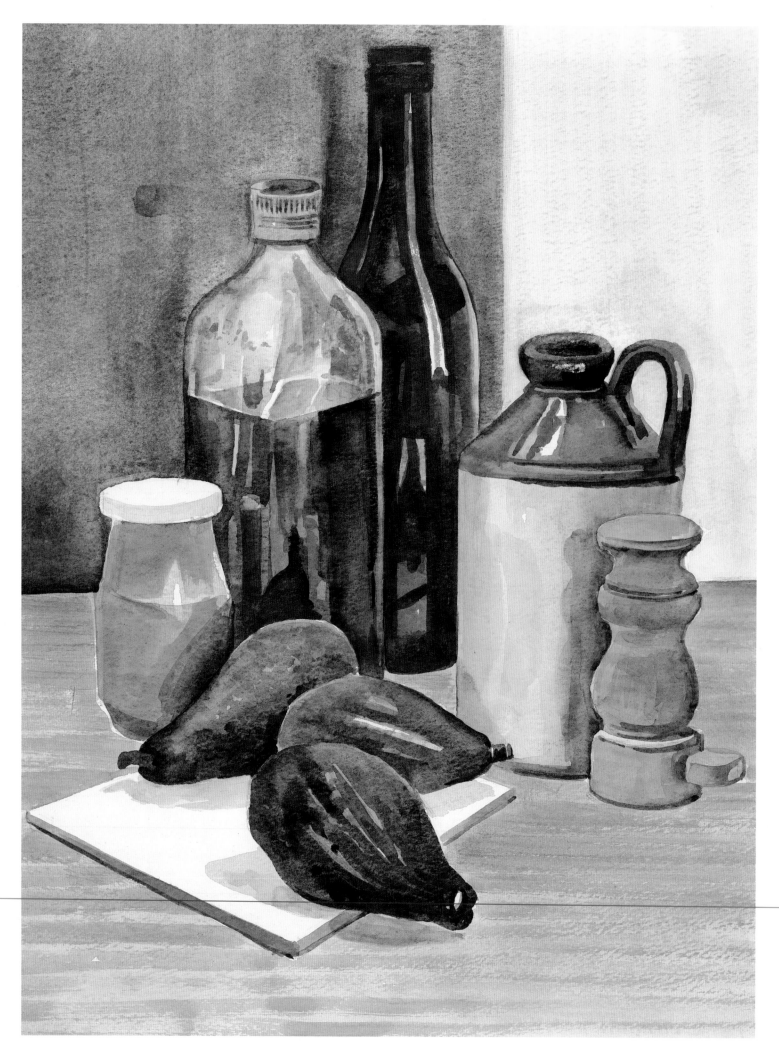

Transparent Washes: Mixing and Applying a Limited Palette of 3 Colors

Mixing three colors from the yellow, red and blue ranges gives a range of 49 tonal gradations. Here we use raw sienna, burnt umber and french ultramarine as our base colors. The next stage is to follow the exercise outlined on pages 62-63, and apply those colors into a still life group.

Materials Watercolor, A3 paper, brushes, pencils, etc, still life of objects suitable to test the range of colors selected.

Method

This is how to mix three colors to give a sequence of 49. The color chart shown here is based on mixing the row between raw sienna and burnt umber first, with the object of getting even mixes between them. A guide is to mix the middle of the range first by eye to give an even mixture, and then continue mixing in alternate steps. Thus if there are nine steps from one color to the other, mix number five first, then three and seven, before filling in the whole row. With these completed gradations, mixed on a palette or mixing tray (always mix more than is needed), fill in the middle row of a squared-up chart on watercolor paper. Next mix each one with clean water to achieve lighter tones toward the top row, using the white paper to achieve these. Finally, work toward the lower half of the chart in the same way, using the mixtures of the middle row, but this time increase the french ultramarine in greater proportions in each succeeding row down to the lowest. If the mixtures are in a sequence of even gradations, the steps should be apparent from left to right, top to bottom and also diagonally.

The other sets of three colors can be used in the same way, which should be easier to achieve because there is a greater contrast between the yellow and red in each of them, giving wider steps between. Try using the sequence of cadmium yellow (deep), alizarim crimson and cobalt blue first, before attempting the others. Of course, other combinations of colors can be used, as long as the same sequence is followed.

Set up a still life group, using some of the skills you have already acquired to help, and follow the procedure on the following pages, working from light to dark with three colors.

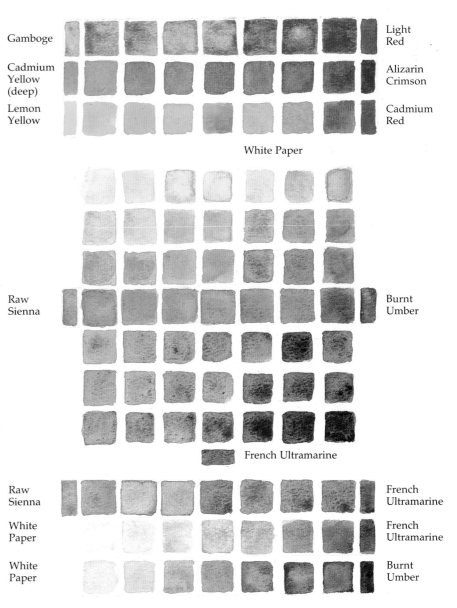

LEFT
Another pencil drawing that allows a combination of fine linear work with some shading, plus the use of open spaces of white paper.

FAR LEFT
This basic still life in watercolor uses the three primary colors selected: raw sienna, burnt umber and french ultamarine.

BELOW
This color chart shows the mixing of three colors to give a sequence of 49.

Gamboge — Light Red

Cadmium Yellow (deep) — Alizarin Crimson

Lemon Yellow — Cadmium Red

White Paper

Raw Sienna — Burnt Umber

French Ultramarine

Raw Sienna — French Ultramarine

White Paper — French Ultramarine

White Paper — Burnt Umber

From Collage to Watercolor

This is the only exercise where a photograph is used as a starting point and to illustrate the use of photography as a source material. The photograph is developed, via collage, into a still life using all twelve colors (see pages 58-59 and 62-63), plus square-ended or hake brushes instead of the rounded-point type, to echo the mosaic effect created by a collage of paper.

Materials Watercolors, photograph, color magazines, glue, paper, brushes.

Method

Choose a photograph of a still life (an artist's work can be used if you wish) in the form of a postcard, calendar, magazine picture or advertisement. It needs to have a strong contrast of tone and color and show a textured group of objects. The image should be clearly defined, suitable to be transposed into a collage.

Working to the proportions of the photograph, draw out the main shapes on tone paper, keeping it simple. Using a large stock of color magazines, look out for examples of tone, texture and color, in that order, to match as closely as possible with the still life. The aim is not to find the real equivalent, but to build up the suggestion of similarity as an illusion. When tearing the paper, no scissors please; find the run of the paper fiber to get straight torn pieces.

Beginning with the background areas, stick down the pages you have chosen, now torn into square/rectangular pieces. You will soon master the technique and can spend more time trying to match your gatherings up with the photograph. Remember that both photograph and collage will be used for the final watercolor, so concentrate on the tonal side which is easier to match. At various stages, step back to see both of them together.

Once your collage is complete, transfer the proportions on to watercolor paper and follow the stages of the still life created on page 62-63. To create the textural aspect of the collage, use tissue and sponges to soak and stain it, cocktail sticks and nails to score the paper for etched lines, a small blade and nail file to scratch and scrape into the surface, wax resist and masking fluid to block out fine lines and textured areas, and a tooth brush or stiff brush to give splattered and stippled effects.

LEFT
This photograph of fresh and cooked fish and shellfish has been used as a starting point for this exercise.

BELOW
The collage acts as a catalyst for the watercolor, in that it helps to transpose what you see into more 'painterly' terms. Torn paper is used to translate tone, texture and color, showing you the possibilities of the suggestive qualities of the medium.

RIGHT
Cézanne's technique of watercolor exploited flattened washes which was close to his oils technique. The picture shown here makes use of square-ended brushes.

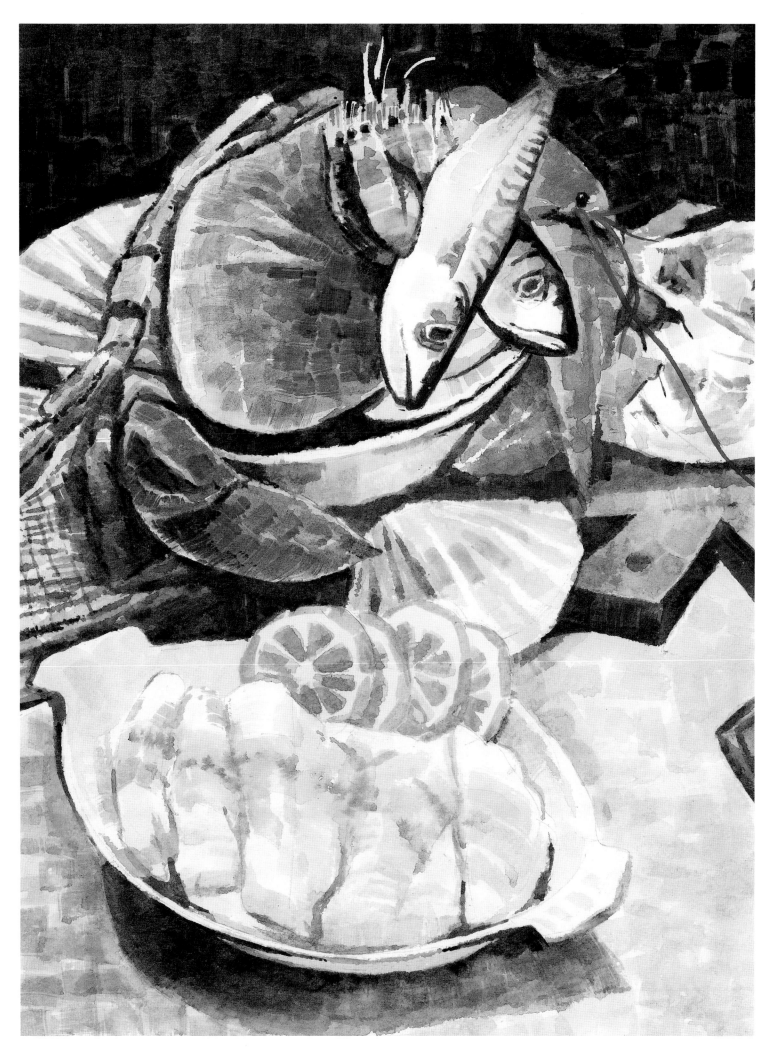

Transparent Washes: Increasing the Palette to 6 and 9 Colors

In its pure sense, the term watercolor refers to a translucent medium used without white and is applied in washes on white paper, which gives the paint great luminosity. It was this pure form that was primarily developed by the English watercolorists in the eighteenth century. Pigments diluted with water gave rise to the term 'wash'; if white is added then the pigments lose their transparency and the resulting water-based paint is called 'gouache'.

The earliest recorded use of watercolor is in the cave painting of Altamira and Lascaux, where pigments of rich ocher, red and black were used to create tribal images of bison and antelope. Long before the birth of Christ, the Egyptians were using fresco techniques of watercolor on plaster to decorate their tombs and buildings, but this method was developed to its peak by the masters of the Italian Renaissance. Rubens and Rembrandt in the seventeenth century used line and wash for preparatory drawings, in turn influencing the English School, above all Gainsborough, Constable and Turner. In the twentieth century watercolor has again become a medium of experiment in its right.

This exercise explains the technique of applying transparent washes, irrespective of the number of colors used or the palette arrangement. In this case there are six colors to work from initially, extending into nine.

Materials Watercolors: palette of six colors using Sets 1 and 2 for vegetable still life (page 15); palette of nine colors using Sets 2, 3, and 4 for salad still life; palette of six colors using Sets 2 and 3 for fruit still life – gamboge, light red, viridian, cadmium yellow (deep), alizarin crimson and cobalt blue. Still lifes using fruit, vegetables, salad and utensils; pencil, brushes, paper, tissue, etc.

Method

Lightly outline shapes with a hard pencil, plus some outlining of those areas to be left white; use the guidelines on measuring and placing (pages 12-13). The first set of washes indicates the lightest tone of each color, starting with the palest color and using a loaded brush to give a flowing technique to avoid patchiness and fussiness. Keep each of the washes separate by leaving a white line between them to prevent any of them running together, and avoid the areas of

BELOW LEFT
The flat washes give maximum coverage with a dry barrier of white paper to prevent colors seeping into one another. Any lighter areas or those to be left white are avoided or lifted out with a dry tissue.

BELOW
The illusion of depth begins to appear as contrast is added to develop the appearance of the still life. Any experiment should be in the earlier stages. Try tilting the paper to allow the weight of the wash to give emphasis around a white line – notice that the flow of water is prevented from trickling beyond it.

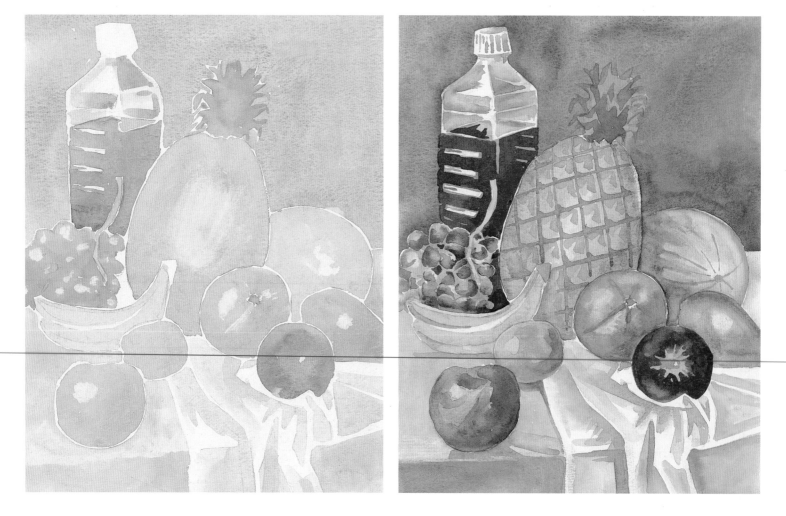

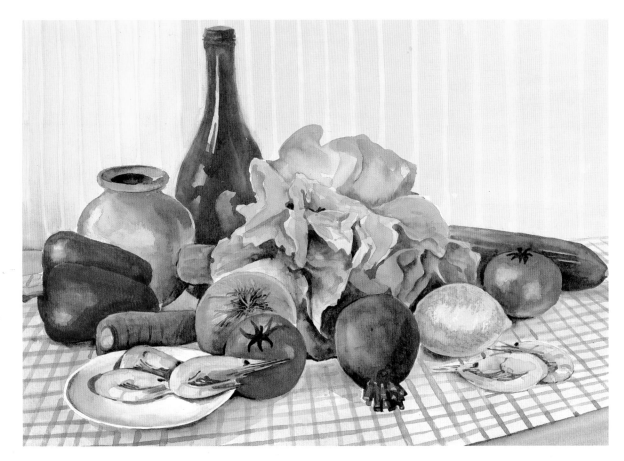

white (this can also be done by lifting the wash off with a tissue while it is still wet). At this stage it is easier to work on the flat to prevent washes trickling down the paper, but for the drawing stage it does help to work fairly upright.

In the next stage, look for those areas in halftone and lay in the washes, starting with the palest color, while some of the lighter washes are still damp or wet. Tilting the paper can, to a certain degree, help in controlling the spread of one wash into another (see Separating a wash, page 56). Create soft edges by using some wet or damp surfaces, especially for the background, and use the sharp edges toward the front by maintaining a white separating edge where needed. When the second stage is finished, dry the paper with a hairdryer.

The darkest tones are the most crucial of all of the stages. In earlier stages a degree of free play is possible because later washes can correct the previous ones. The advantages at this stage, however, is that you have a framework and an indication of form before committing yourself to the areas of shadow. A helpful technique at this stage is to use another brush with clean water to blend the top layer into the lower layers. A roll of tissue is always handy for absorbing excess water and for mopping up a mistake, for example when the wash is too dark too early.

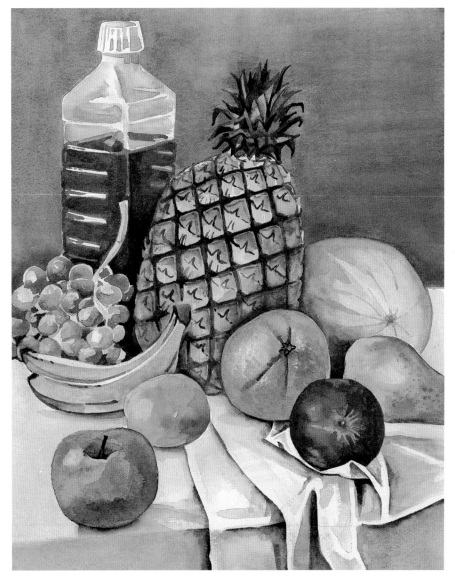

Collage in Distortion and Abstraction

Many artists have recognized the disparity between their view of the subject and its transposition on to a flat surface. It was Cubism that attempted to resolve the inherent contradiction between three-dimensional form and space and the two-dimensional picture plane. When Picasso and Braque introduced the concept of a single image representing more than one viewpoint, they abandoned a long-held and rigid notion of the visible world and rejected conventional perspective, which dictated that the onlooker was viewing the world from a set position, thus breaking down one of the foundations of traditional and academic art.

By releasing artists from the obligation of an imitative art which created an illusion of form and space, the Cubists allowed them to have a different function. Artists were able to invent original and independent forms without the restriction of a defined spatial context, and to create pictures which became less representational and increasingly abstract. In order to get back to the subject (in many cases still life) and 'reality,' collage was introduced as a means of bringing in a tactile sense of the known, physical world.

In the later phase of Cubism, known as synthetic Cubism, Picasso and Braque began to introduce first stenciled lettering and then collage, in the form of additional materials such as fragments of newspaper and printed wallpaper. Stenciled letters made their first appearance in Braque's *The Portuguese* in 1911; in 1910 he began to incorporate into his work illusionistic elements such as imitation wood and marble. Picasso first used the technique of collage in 1912 in his *Still Life with Chair Caning*, which used a real object, a piece of oilcloth pasted on to the canvas, to represent chair caning, above which the artist painted a wine glass and a lemon.

By using readymade objects, Picasso demonstrated that a work of art need no longer rely on elaborate techniques or materials, and thus broke with the tradition established from the Renaissance of insisting on the unity of materials throughout a picture. Moreover the technique of collage allowed him to work rapidly.

Textures were borrowed, by using cut-out paper from sheet music, newspapers, decorative patterns, wallpaper, lettering or veneers, for example, and they were used as components in a pictorial framework of broken facets or fragmented planes to present multiple viewpoints or simultaneous representation.

Materials Conté, black and white, charcoal; tone paper, collage, still life taken from mealtime.

Method

Here we inject a new element into our cubist study with collage introduced into the drawing. The divisions of the picture plane should be less formulaic and predictable, and the position of the fragments should be more intuitively decided and dictated by the ongoing development of the work. Alterations can be according to demands of design, structure or pattern, while not forgetting the tonal relationship between object and plane. Use a combination of charcoal and black and white conté on tone paper, with collage added toward the end.

'I try to make concrete that which is abstract' – Juan Gris.

BELOW
This drawing illustrates how collage can borrow second-hand images to represent a tactile 'reality', without a deceptive illusionism or an imitation of reality.

RIGHT
Georges Braque
The Round Table 1929
Oil on canvas, 57¼ × 44¾ inches
(145.4 × 113.6 cm)

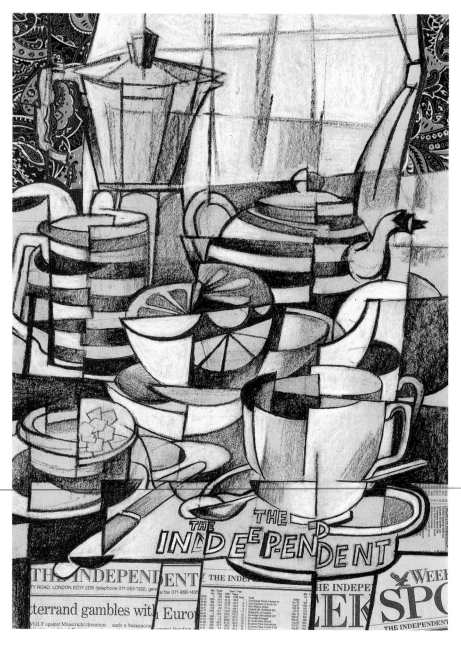

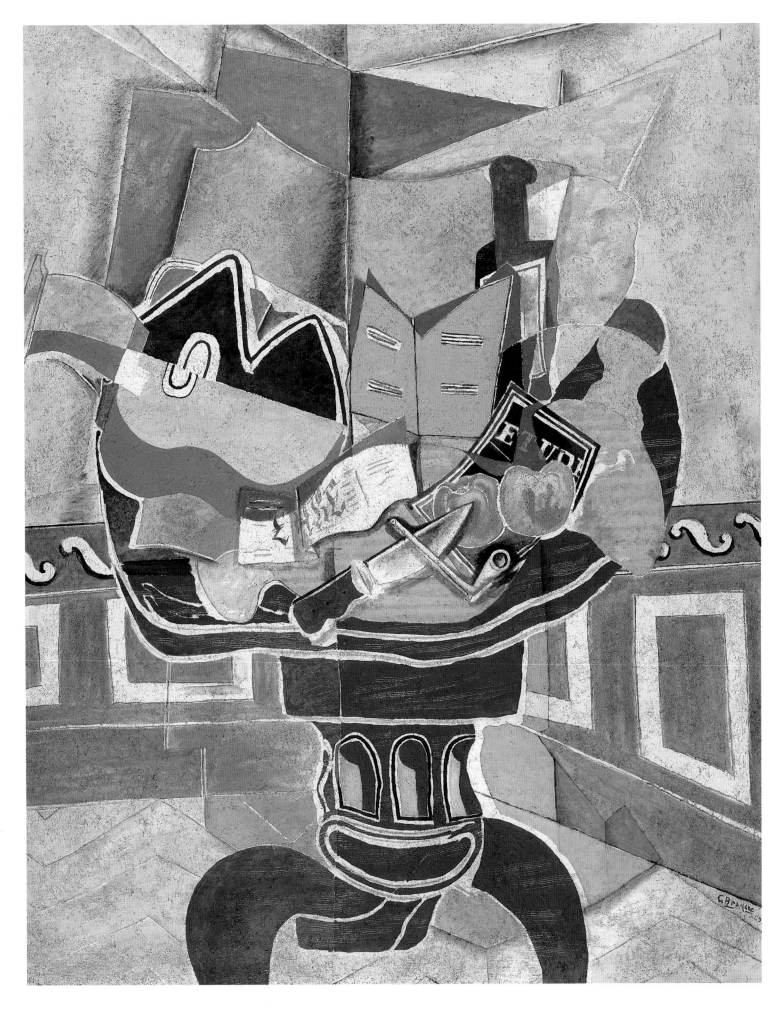

5. Distortion and Abstraction

Fragmenting Form and Space

One of the limitations of traditional or representational art is that it imitates the fixed appearance of the world, as though everything was held for a static moment in time. Paul Cézanne, in the work he did toward the very end of his long life (notably his late *Bather* series), began to treat traditional subjects, both figure studies and landscapes, as designs of interlocking planes covering sky, water and solid forms. Cézanne's rigorous analysis of structure, together with a general interest at the beginning of the twentieth century in primitive art and particularly African sculpture, inspired Pablo Picasso and Georges Braque jointly to reject the naturalistic tradition of the previous 400 years and thus to revolutionize painting and sculpture. The result was a movement called Cubism, which freed onlookers from an imposed and fixed single viewpoint and instead allowed them to freely move around in space to visually experience form more completely through fragmented planes. The concern of Cubism was to create a new method of representing three-dimensional volumes on a two-dimensional surface without resorting to illusionism. Braque and Picasso aimed to show objects as they were known and comprehended by the intellect rather than as they appeared at a particular time and place. They thus abandoned traditional perspective and adopted a multiplicity of viewpoints, so that different aspects of the same object could be viewed simultaneously.

On pages 11-12, we looked at the difference between the conceptual, actual and perceptual views of a cylinder, and it will transpire that all of them can play a part in creating different viewpoints of the same object. Similarly, on pages 26-27 we considered the construction of a cylindrical form, breaking it down into flat planes and explaining how tonal values determined by the viewpoint of the onlooker.

Materials Pencils and other drawing mat-

erials, A3 paper or larger, contents of washbag, shopping bag, sewing bag, toolbox, make-up bag, card/games box, smoker's pouch or any suitable still life.

Method

Choose and arrange a compact and overlapping group of objects with some decorative pattern and lettering involved. Make a tonal drawing of the still life on a small scale. Transfer and enlarge the drawing on to paper with just the simplest outlines, which will be altered from their initial placings and therefore need not be too accurate.

RIGHT
A straightforward drawing of the still life with tone, as the means of gathering information and making use of pattern, decoration, etc.

FAR RIGHT
With the barest outlines used from the drawing, not too much detail, place the vertical and horizontal divisions like scaffolding to build up the planes.

Conceptual

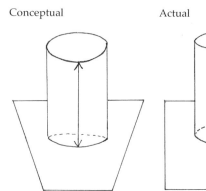

Middle smaller than sides of cylinder. Table diverging – front smaller

Actual

Middle same as sides of cylinder. Table equal – back and front.

Perceptual

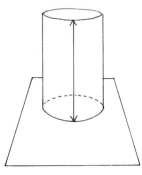

Middle larger than sides of cylinder. Table converging – front larger.

Cylinder

Sphere

Cone

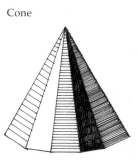

1 Viewpoint

2 Viewpoints

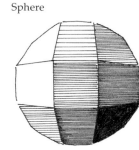

4 Viewpoints

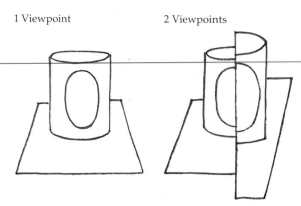

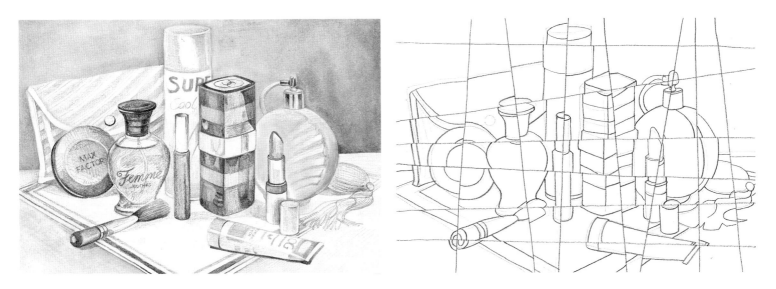

The next stage is to decide where to cut into the forms; before making a final decision about the dividing lines, look for the possibilities of cutting two or more objects in line, rather than introducing the arbitrary divisions. First look at the variations on the vertical and horizontal with angles that take in more than one object. Once the dividing lines have been made, each object can be adjusted to them and given different positions and sizes, with the idea of creating different viewpoints. One of the more useful ways of indicating a change of viewpoint is through the alterations in letters, pattern or stripes.

In order to give a fuller sense of form and space, both objects and fragmented planes need to be emphasized with tonal contrast (and not by the use of the drawn line), based partly on the original drawing, but reflecting also the new set of circumstances, which determines light and shade by the altered state of objects rather than by how they were illuminated before.

'I do not seek, I find' – Pablo Picasso.

BELOW
The fragmented planes have a dual purpose, simultaneously showing the different viewpoints, with each facet, and the objects as well. Tone is used once again to separate plane, object and viewpoint.

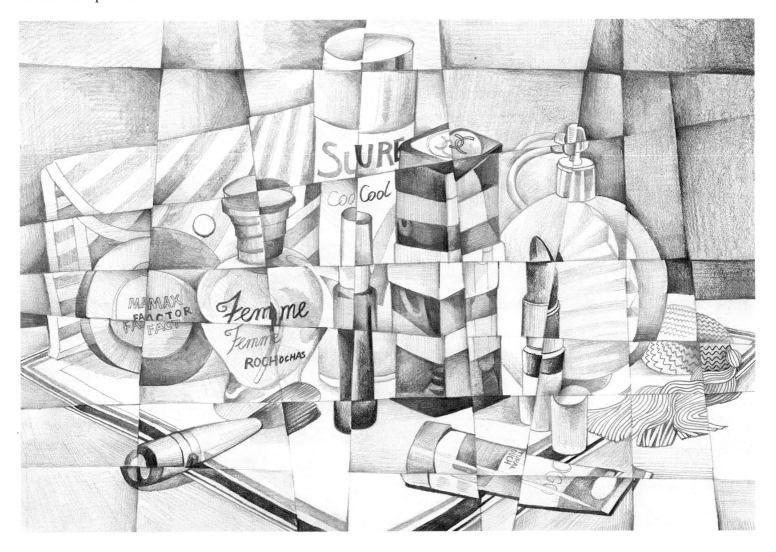

Color Reactions

Following the prominent role which Impressionism had given color, artists as diverse as Gauguin, Kandinsky, Munch and Seurat adopted a common aim in using spectrum colors. Since the introduction of Japanese woodblock prints, European artists had become increasingly interested in using flat colored shapes as an alternative system of representation. When the French Fauve artists and the German Expressionists looked at the elements of picture-making, color was regarded as the most significant factor, in particular the use of complementary colors.

In order to find the complementary for yellow, red and blue, remember that when two of these colors are mixed, the color left will complete the primary set. So red and blue mix to give violet, to complement yellow, and so on. Because they react naturally to enhance each other, complementary colors are used instinctively in everyday life, for instance when displaying food in a restaurant or market stall. Artists have both consciously and unconsciously sought to bring this phenomenon into play by exploiting the balance, distribution and reaction of colors. More often than not it is the interplay between complementaries that is the focus of interest, and it is this that we look at first.

Materials On black, gray and white paper place each set of complementary colors in equal proportions alongside one another, to discover their reaction as color and non-color (chromatic and achromatic), and change the respective amounts to consider balance. You will see that red and green show up best against black, with an even distribution of color for balance. Yellow and violet appear to be stronger on the gray paper, with more than double the yellow to balance the violet. All the colors seem to stand out on white, but the orange and blue have the edge and complete the sequence of colors to non-colors. More orange is needed to balance out the blue.

BELOW
Reaction of Color
The following arrangements give the complementaries their optimum contrast: red and geen on the black background; yellow and violet on the gray background; orange and blue on the white background.
 The opimum contrast for all the colors is on white, rather than black and gray.

RIGHT
Paul Cézanne
Still Life with Plaster Cast
c.1894
Oil on paper on board, 27½ × 22⅓ inches
(70.6 × 57.3 cm)
This classic still life is used as the basis for our color exercise on pages 72.73.

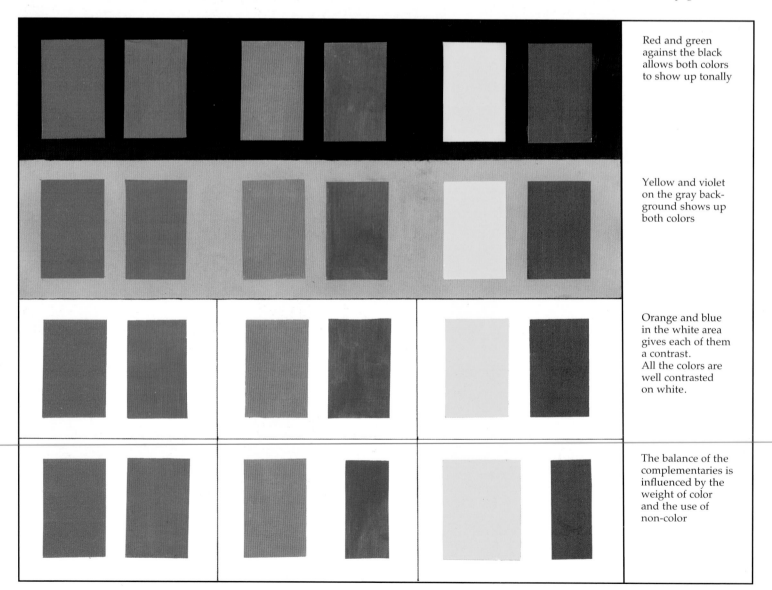

Red and green against the black allows both colors to show up tonally

Yellow and violet on the gray background shows up both colors

Orange and blue in the white area gives each of them a contrast. All the colors are well contrasted on white.

The balance of the complementaries is influenced by the weight of color and the use of non-color

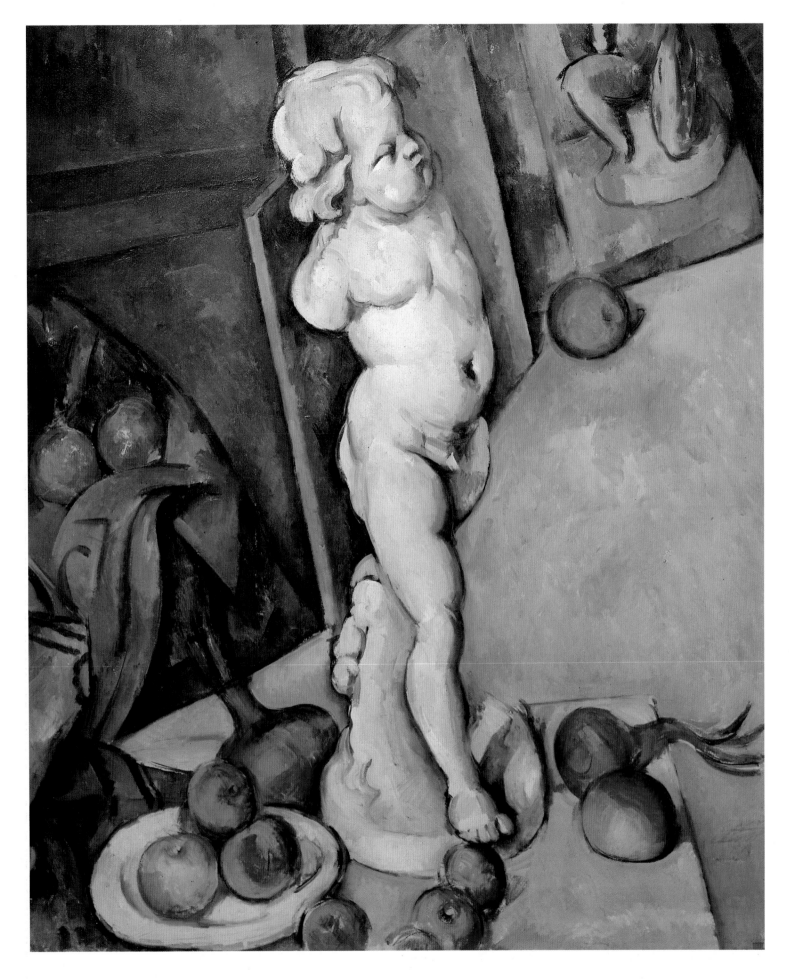

Unrelated forms

This is another exercise that explores the possibilities of photography as a source material, by an intuitive choice and imposing little technical control, but requiring decisions about selecting and juxtaposing cutout images.

Surrealism was another 'modern' movement that explored still life, but in such a way that the objects had no relationship with one another and appeared to exist only in the imagination as if in a dream (a nightmare even) or fantasy. Amongst the many visual and literary sources that influenced these worlds were artists like Arcimboldo, Blake, Bosch and Goya. Other influences were a wide range of literary genres, including science fiction and the French poetic tradition, represented for example by

'One must not imitate what one wants to create. One does not imitate appearances; the appearance is the result;
– Georges Braque.

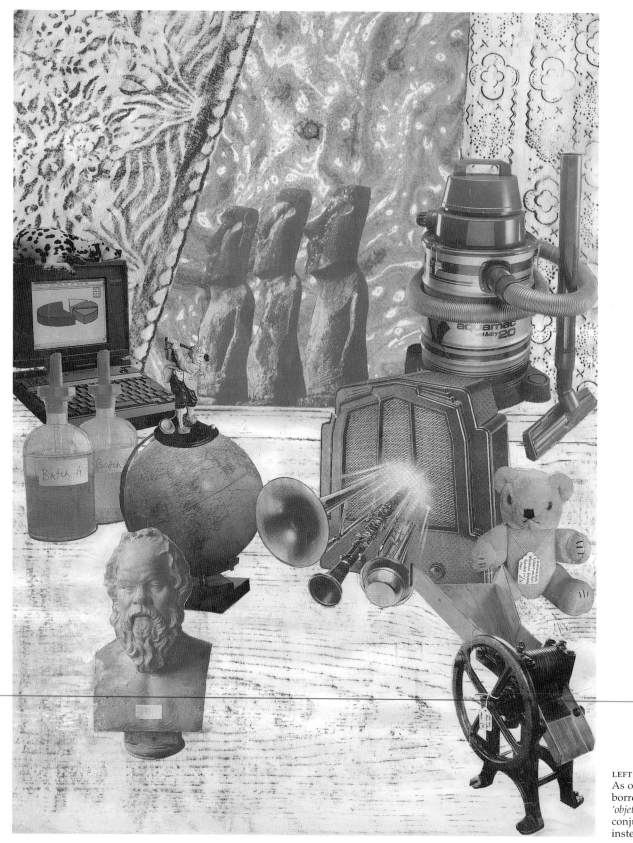

LEFT
As on page 64, collage has borrowed the found object, *'objet trouvé'*, but this time it conjures the dream world instead of the visible world.

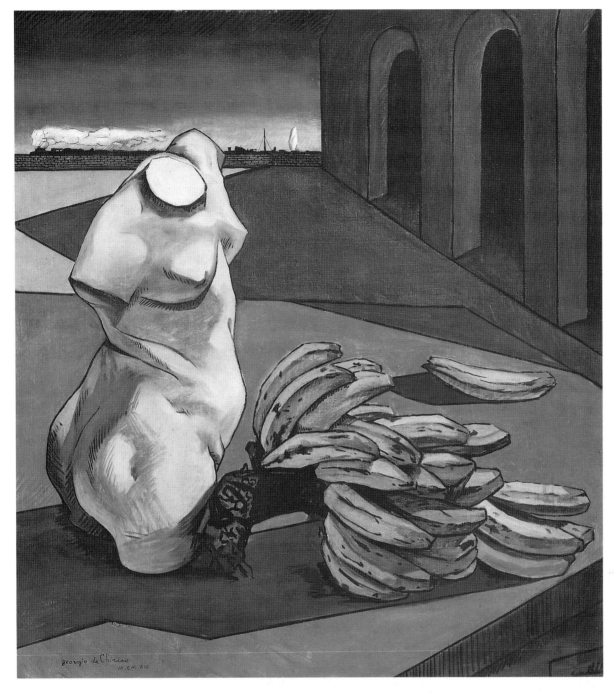

LEFT
Giorgio de Chirico
The Uncertainty of the Poet
1913
Oil on canvas, 36½ × 41⅛
inches (94 × 105.4 cm)

Lautréamont, which acknowledged the supremacy of irrational association and imaginative insight. These were to become touchstones for Dada and Surrealist artists such as Chirico, Dali, Ernst and Magritte who adapted a 'realistic' representational style in order to express the workings of the unconscious mind or the products of a dream world in the form of precisely observed but bizarre and dislocated imagery.

Materials Black and white photographs, scissors, glue, conté.

Method

The variety of methods used in this example include **collage**, cutting out different types of paper to stick down and, more specifically, **montage**, cutting out photographs to stick down. First of all, make a random selection of black and white photographs from catalogues, magazines and newspapers, images which are both appealing and disparate.

Other methods worth experimenting with include **decalcomania**, mixing black oil paint or printing ink with turps poured on water, and lifting a print from the top surface of it to suggest marbling, and **frottage**, rubbings taken from textured surfaces of wood, metal or natural forms, with paper and black conté. Make a choice of subjects and cut out your shapes. Use decalcomania and/or frottage to create the underlying surface and lay your cut-outs on the surface. Before sticking them down, try different ways of placing, overlapping and composing them to create an effective image.

'As beautiful as . . . the fortuitous encounter upon an operating-table of a sewing machine and an umbrella' – Comte de Lautréamont.

Warm and Cool Colors

It is appropriate here to explain the different 'families' of colors. Red is head of the warm family; cadmium red is warmest, whilst alizarin crimson is cool. Yellow is head of the neutral family, with cadmium yellow (a deep color) warmer, lemon yellow distinctly cool. Blue is head of the cool family; cobalt blue is cool, yet french ultramarine is relatively warm.

Each color can vary in temperature and can fluctuate between warm and cool; each family can accommodate a warm and cool member. This increases your options and should be borne in mind when considering the range of colors. When looking at color balance, it is important to allow for this and increase your range further to involve noncolor.

Materials Gouache, pastel, watercolor, black, gray and white paper, still life reproduction.

Method

Using a still life picture, such as the classic Cézanne *Still Life with Plaster Cast* illustrated on page 69, transfer it into line only as self-contained shapes on A3 layout or thin paper. Trace the outlines with a hard pencil or ballpoint (with the reverse side of the drawing chalked), to show up on black, gray and white paper.

On the black paper use gouache which, since it is an opaque medium, will cover the black, using the range of red and green with the background of the paper showing as a non-color. Pastel is best suited for the gray paper and the yellow and violet range, again with non-color as background. Finally, watercolor on white paper is best for the complementaries orange and blue, as well as non-color.

In each case shapes must be separated by the non-color of the paper, with flat areas of complementary color, although a small amount of shading is permitted. Remember that the first color that is laid in may not necessarily be the final or only color to be considered.

When considering all the complementary sets, look at the warm and cool bias of each color. Consider mixing them together and with white to get a lighter range, and apply the same principle by mixing darker, finishing off with black. Pure colors should also be used and chromatic grays can be created by mixing complementary colors together. The general guideline is to pursue balance and distribution without resorting to a great deal of detail.

BELOW LEFT
This pencil drawing gives the simple outline shapes taken from Cézanne's *Still Life with Plaster Cast* (page 69).

BELOW
Red and green are used in gouache on black paper.

BELOW RIGHT
Yellow and violet with the use of pastel on gray paper.

BELOW FAR RIGHT
Orange and blue have been used in watercolor on white paper.

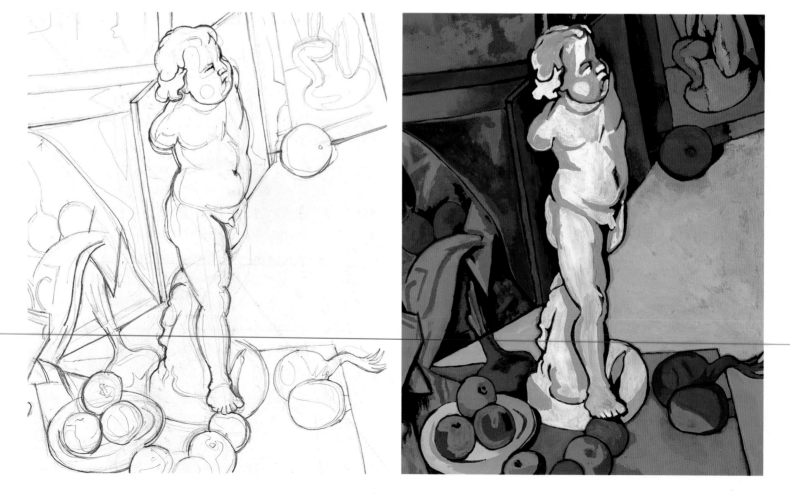

'What I dream of is an art of balance, of purity and serenity devoid of troubling or depressing subject matter, an art which might be an appeasing influence, like a mental soother, something like a good armchair in which to rest from physical fatigue' –
Henri Matisse.

LEFT
Paul Cézanne
Apples and Oranges (detail), 1895-1900
Oil on canvas, 28¾ × 36¼ inches (73 × 92 cm)

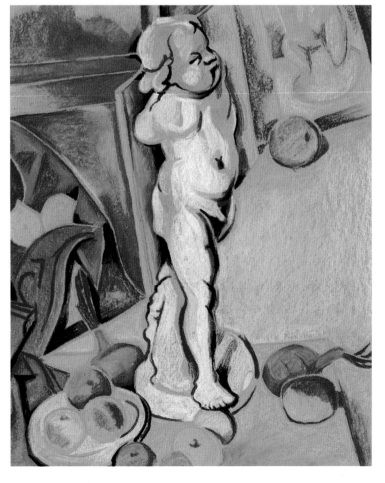

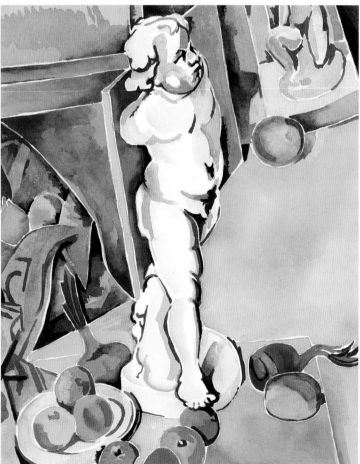

6. Themes and Variations

A Composite Picture

The range of the still life genre can be increased by creating a composite picture which brings in other subject matter. In choosing a theme as the basis of the picture, you should concentrate on still life matter at the core, but then range well outside the scope of such a theme; the subject may be taken and changed into an object. When does a person become a still life object? – When that person becomes a statue, a bust, a figurine or a medallion. Alternatively, convert a large building or vehicle into a model: the Eiffel Tower as a souvenir, the Boeing 747 as a toy plane. This ability to transform and transfer subjects opens up the possibility of still life as a theme with endless variations.

Materials Still life objects, reference books, pencils; A3 paper or larger, pen and wash.

Method

Choose from a range of themes, which could include a personal interest and/or favorite topic from one of the following: city, country, decade, hobby, job, celebrity, season, etc. Make a list of all the relevant contents for the theme, incorporating three-and two-dimensional objects such as symbols, souvenirs, memorabilia, emblems. Decide on a suitable format – horizontal or vertical. Make a number of thumbnail sketches before committing yourself to a more finalized version. When working out the rough sketch, do *not* bother with a lot of details; you can deal with the information as a written explanation.

BELOW LEFT
Thumbnail sketches, with written explanations, at this stage to sift and sort out the information, the variations and composition.

BELOW
The second stage shows the final selection; a process of selection and rejection has been applied, so there would be more steps between this and the previous drawing.

LEFT
To achieve a more complete
finish, the addition of tone
through washes gives a
conviction of form to the
foreground and aerial
perspective takes the eye
into a receding background.

For example, you could choose the theme of golf, restricting it to the Ryder Cup to make it more manageable. Here is a sequence of stages.

Theme Ryder Cup

List Equipment of golf clubs, shoes, gloves, etc, clubhouse, greens, maps and plans of courses, personalities, souvenirs, etc.

Format Vertical composition with diagonal from bottom left to top right to suggest sporting activity.

Presentation As actual still life objects but with flat shapes.

Use reference books for source material. Remember some of the object lessons of previous exercises in placing, overlapping, technique, composition, form and space.

A Composite Picture on a Traditional Theme

One of the most productive periods in still life painting was in the seventeenth century, when it first evolved, playing a minor role in history painting where figures predominated. Still life began to accompany the more prominent subjects, with themes like outdoor concerts, banqueting, and kitchen scenes. Perhaps the French renown for their cuisine and the Dutch for their garden produce led them to give still life a more domi-

nant position respectively known as *nature morte* and *still-leven*. The ability of northern masters such as van Eyck to render objects realistically, particularly as regards light, was admired even at the time.

The Golden Age of Dutch realism provides rich pickings for themes, which were

ABOVE
The five senses in pen and ink as a linking theme.

BELOW LEFT
The five senses in pencil as a *trompe l'oeil*.

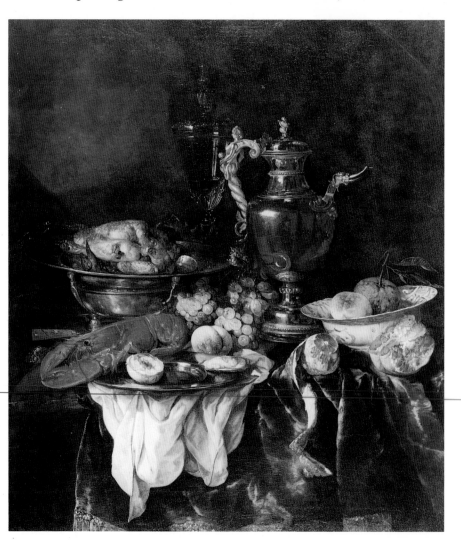

developed into quite elaborate compositions, frequently to reflect the interests of the up-and-coming bourgeoisie and their material wealth. Subject matter ranged through market and kitchen scenes, game and natural forms, depictions of the five senses, four continents and four seasons, dessert and confectionery, banquet and laid tables, fruit and flowers, musical instruments and weapons, breakfast pieces and books, *trompe l'oeil* and pinboards.

There was also room for less materialistic subject matter, as exemplified in *vanitas* and *memento mori* themes in an allegorical mode and showing the transcience of human life as symbolized by a skull, watch, candle, hourglass or peeled fruit. These would be placed in a darkened setting with somber color to evoke sadness and melancholy, to provoke a sense of guilt in the observer at the vanity of material things, and to appeal to spiritual needs.

On the other hand the laid tables featured an array of culinary delights, full of sumptuous and exotic foodstuffs, often introduced by the very merchants who commissioned the work, and brought in from the colonies. The pictures reveal that there was no shortage of food for the table, and show the merchants' standing in society and their affluent life styles. Abraham van Beyeren at first specialized in fish subjects and later devoted himself primarily to the sumptuous banquet theme. Other subjects that were favored were fruit and flowers, reflecting the rise in horticulturally efficient practice in Holland and also evidence of the increasing and successful production of perishables. Still life painting showed off new technology and its capacity to reflect what was happening in the age.

Materials Watercolor, pastel, conté, pencil.

Method

The choice of subject is very wide, as is the range of media and techniques available. Follow the guidelines given in the previous exercise, and look at the alternative ways of creating a composite picture by using a pinboard to arrange your material or a linking thread to unify the theme.

ABOVE
A watercolor depiction of the essence of autumn, season of both abundance and decay.

LEFT
Abraham van Beyeren
Still Life with a Lobster, Fruit, Silver and Chinaware
Oil on canvas
A sumptuous still life from the Golden Age of Dutch art.

Still Life for the Modern Age

Just as Dutch artists epitomized the attitudes and aspirations of their day in their still lifes, it was appropriate that the Pop Art of the 1950s and 1960s should draw attention to the commodities of a mass-producing and consuming society. By using techniques that reflected the technological input of the mass media, Pop artists related their methods to printing and advertising and the influence of image presentation through television, posters and the profusion of magazines on the market. Many American artists, such as Warhol, Oldenburg and Rosenquist, started work from a commercial background, whilst older colleagues like Johns and Rauschenberg had already introduced a new concern with figurative art after the rigors of Abstract Expressionism.

There are many everyday subjects with the potential for a modern still life: fast food outlets, supermarkets, pubs, bars, retail stores and advertisments.

Materials Pencils, pens, sketchbook.

Method

In this last exercise it is important to think of your drawing like a reporter with his notebook: go out and record what is available and do this quickly, directly and simply. Try to get the essential aspects of the subject with the minimum of time, using a rapidity of execution which demands a darting eye and a flowing medium.

Perhaps the development of quick sketching is a reflection of the fast delivery that seems to be the order of the day. As well as using a sketchbook for quick studies, it is worth remembering that it is a useful part of your equipment for making preliminary sketches. When trying to make rapid outlines of a random situation where things are moved or quickly rearranged, it often helps to get information down with a written explanation as well. Consider the use of a camera as a way of accumulating instant recall, creating an invaluable source of documentation for later reference.

BELOW AND RIGHT
All these drawing were done as sketchbook work in pen and ink and taken from direct 'on the spot' experience.

Index

Figures in *italics* refer to illustrations and diagrams

Acknowledgments

The publisher would like to thank the following agencies and institutions for supplying illustrative material.

Courtauld Institute Galleries, London (Courtauld Bequest]: page 69
Glasgow City Art Gallery/ Bridgeman Art Library: page 45
Kunsthalle, Hamburg: page 51
Kunstmuseum, Dusseldorf/ Bridgeman Art Library, © Succession Henri Matisse/ DACS 1993: page 11
National Galleries of Scotland: page 21
Musée d'Orsay, Paris/photo RMNS: pages 6, 73
Phillips Collection, Washington DC, © DACS 1993: page 65
Prado, Madrid/Bridgeman Art Library: page 43
Private Collection/Bridgeman Art Library © David Hockney 1993: page 10
Pushkin Museum, Moscow/ Bridgeman Art Library: pages 30/© Succession Henri Matisse/DACS 1993, 45
Scottish National Gallery of Modern Art: page 8
Shelburne Museum, Shelburne, Vermont/photo Ken Burris: page 29
Tate Gallery, London: page 71/© DACS 1993; page 9, 47/Bridgeman Art Library
Vincent Van Gogh Foundation/ National Museum Vincent Van Gogh, Amsterdam: page 7